THE NATIONAL GALLERY SCHOOLS OF PAINTING

Flemish Paintings

THE NATIONAL GALLERY SCHOOLS OF PAINTING
Flemish Paintings

CHRISTOPHER BROWN

Deputy Keeper, The National Gallery

National Gallery Publications
The National Gallery
London

National Gallery Publications
Published by order of the Trustees
© Christopher Brown and The National Gallery 1987

British Library Cataloguing in Publication Data
National Gallery
 Flemish paintings. —(The National
 Gallery schools of painting).
 1. Painting, Flemish 2. Painting, Modern
 —17th–18th centuries—Belgium
 I. Title II. Brown, Christopher, 1948–
 III. Series
 759.9493 ND666

ISBN 0-947645-41-1

Printed and bound in Great Britain
by William Clowes Limited, Beccles and London

Front cover: Rubens, *Samson and Delilah* (detail)
Back cover: Van Dyck, *"The Balbi Children"*

THE NATIONAL GALLERY SCHOOLS OF PAINTING

This series offers the general reader an illustrated guide to all the principal schools of painting represented in the Gallery. Each volume contains fifty colour plates with a commentary and short introduction by a member of the Gallery staff. The other volumes in the series are:

Dutch Paintings by Christopher Brown
French Paintings before 1800 by Michael Wilson
Spanish and Later Italian Paintings by Michael Helston
Italian Paintings of the Sixteenth Century by Allan Braham
Early Netherlandish and German Paintings by Alistair Smith
French Paintings after 1800 by Michael Wilson
British Paintings by Dillian Gordon

The first six volumes were published in association with William Collins.

Earlier Italian Paintings by Dillian Gordon and Alistair Smith, to be published in 1988, will complete the series.

CHRISTOPHER BROWN is Curator of Dutch and Flemish seventeenth-century paintings at the National Gallery. He has organised and catalogued a number of exhibitions, including "Art in Seventeenth-century Holland" (1976), "Dutch Genre Painting" (1978–9) and "Dutch Landscape: The Early Years" (1986). He has written widely on Northern painting of the sixteenth and seventeenth centuries, and his books include *Carel Fabritius* (1980) and *Van Dyck* (1981).

Introduction

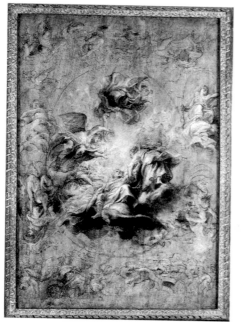

Peter Paul Rubens, The Apotheosis of James I, sketch for the ceiling of the Banqueting House, 1629/30. On loan to the National Gallery.

In January 1625 Peter Paul Rubens wrote in a letter to his friend Valavez in Paris that the Prince of Wales "is the greatest amateur of paintings among the princes of the world". He went on to say that through his English agent resident in Brussels the prince had "asked me for my portrait with such insistence that I found it impossible to refuse him. Though to me it did not seem fitting to send my portrait to a prince of such rank, he overcame my modesty". When the Flemish painter travelled to England four years later as a diplomat in the service of the King of Spain, his patron, who had by then ascended the throne as Charles I, knighted him and gave him the greatest single artistic commission of his reign – the decoration of the Banqueting House in Whitehall with scenes glorifying the king's father, James I. Rubens made the initial sketch for this ambitious undertaking while he was still in England and submitted it to the king for his approval. The large canvases were painted in Rubens' studio in Antwerp and shipped to England, being finally installed in 1635. It is the only one of Rubens' large-scale decorative projects still in its original location. Knowing that the king would be more susceptible to visual than verbal argument, Rubens presented his diplomatic objectives to Charles in his great allegory of peace *Minerva protects Pax from Mars* (Plate 14).

In 1632 Charles's passionate enthusiasm for contemporary Flemish painting was crowned by his success in tempting Rubens' most outstanding assistant, Anthony van Dyck, to settle in England. The terms of van Dyck's employment were quite unprecedented in the history of royal patronage in England. He was knighted, granted an annual pension of £200, and given a studio at Blackfriars, where the king could visit him by boat, as well as a summer residence in the royal palace in Eltham. He received a constant stream of commissions from the royal family and remained here until his death in 1641. But his hopes of an ambitious decorative commission – a series of tapestries to be placed around the walls of the Banqueting House – were disappointed when the king ran out of money.

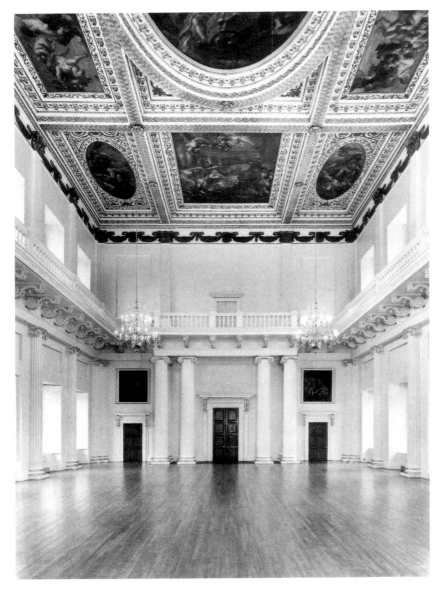

Interior of the Banqueting House, Whitehall. Photo: National Monuments Record.

In his taste for Flemish painting Charles was by no means alone. It was under the auspices of Thomas Howard, Earl of Arundel, whom Rubens regarded as "an evangelist for the world of art", that van Dyck had first visited London in 1620. Arundel had his own portrait (Plate 13) and that of his wife (Munich, Alte Pinakothek) painted by Rubens and had commissioned portraits from van Dyck. Another enthusiastic English patron of Rubens and van Dyck was the Duke of Buckingham, whom Rubens had met in Paris in 1625. Unfortunately the oil sketch in the National Gallery, *Minerva and Mercury conduct the Duke of Buckingham*

to the Temple of Virtue (Plate 11), is all that remains of two important commissions which Rubens carried out for the duke.

Many other Flemish artists visited or settled in England during the seventeenth century. Hendrick van Steenwyck the Younger, the painter of architectural scenes (see Plate 22), was in London by November 1617 and remained in this country for twenty years. A later immigrant was Jan Siberechts, the Antwerp landscape painter (see Plate 49), who probably arrived in 1672 and came to specialise in topographically accurate views of country houses in Britain.

British enthusiasm for the Flemish seventeenth-century school was maintained during the eighteenth century when a number of major paintings by Rubens and van Dyck entered aristocratic collections in this country. For example, Rubens' superb landscape *"The Watering Place"* (Plate 8) was purchased by the 3rd Duke of Montagu in the 1760s. It was seen in the duke's collection by Gainsborough, who not only admired the picture but also painted his own interpretation of it. Gainsborough's *Watering Place* was first exhibited at the Royal Academy in 1777 and was said by Horace Walpole to be "in the style of Rubens, and by far the finest

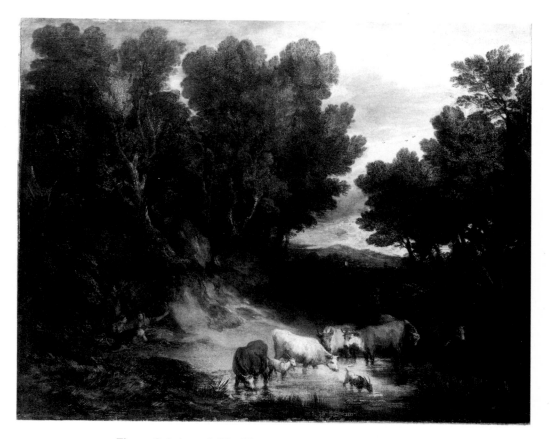

Thomas Gainsborough, The Watering Place, *about 1777. The National Gallery.*

landscape ever painted in England, and equal to the great Masters." It was also during the eighteenth century that the 4th Duke of Devonshire acquired the life-size double portrait of Govaert van Surpele and his wife by Jacob Jordaens (Plate 27), the third member of the triumvirate of artists that dominated painting in Flanders in the seventeenth century. It was admired by George Vertue at Devonshire House in London in 1743. It is not known exactly when Sir Joshua Reynolds purchased the portrait of George Gage (Plate 33) by van Dyck but it may well have been during his trip to the Low Countries in 1781 which he described in his *Journey to Flanders and Holland*. The book contains ecstatic accounts of Rubens' great altarpieces in Antwerp Cathedral and van Dyck's *Crucifixion* at Mechelen which Reynolds considered "one of the first pictures in the world and [it] gives the highest idea of Vandyck's powers".

However, despite the royal and aristocratic patronage of the seventeenth century and the enthusiastic collecting of the eighteenth, the most active period for the formation of important collections of Flemish seventeenth-century paintings in Britain was undoubtedly the period between 1790 and 1850. The French Revolution and the Napoleonic Wars provoked the sale of many Continental collections: British collectors were well placed to benefit from the rush of so many important paintings onto the market. Rubens' "*Judgement of Paris*"(Plate 17), for example, was one of the most important items in the Orléans collection, which was purchased in its entirety in Paris by a syndicate of British collectors in 1792 for sale in London. Rubens' *Rape of the Sabine Women* (Plate 19) was brought to London by its French owner in the 1790s and acquired in 1803 by John Julius Angerstein, whose collection formed the basis of the National Gallery. In the previous year, 1802, the Scottish art dealer James Irvine, acting for William Buchanan, had bought *Minerva protects Pax from Mars* from the Doria family in Genoa – it had been sold with the bulk of Charles I's collection by the Commonwealth in 1650. Genoa proved a particularly rich hunting ground for the work of Rubens: in 1805 Irvine bought *Saint Bavo about to receive the Monastic Habit at Ghent* (Plate 4) and another Scottish dealer, Andrew Wilson, bought Rubens' *Brazen Serpent* there. Irvine's greatest triumph, however, had been the purchase three years earlier, also in Genoa, of Rubens' *Roman Triumph* and *View of Het Steen* (Plates 15 and 18) today two of the greatest treasures of the National Gallery.

All these Flemish paintings entered the National Gallery collection during the nineteenth century by gift, bequest or purchase. The Angerstein collection, purchased by the Government in 1824, contained one Rubens and three major van Dycks; the Duke of Sutherland presented *Minerva protects Pax from Mars* in 1828; and the *View of Het Steen* was the gift of Sir George Beaumont, a tireless campaigner for the creation of the National Gallery and one of its principal early benefactors. The Rev. Holwell Carr, Lord Farnborough and Wynn Ellis bequeathed major Flemish paintings to the Gallery in its early years. The Flemish

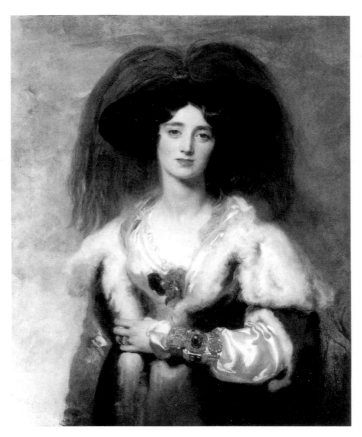

Sir Thomas Lawrence, Portrait of Lady Peel, *1827.*
The Frick Collection, New York.

collection received a substantial boost with the purchase in 1871 of the collection of Sir Robert Peel, the Prime Minister, who had died in 1850. Among Peel's paintings was the so-called *"Chapeau de Paille"* (Plate 10), the famous portrait by Rubens of his sister-in-law Susanna Lunden. This much admired and often reproduced panel had been purchased in Antwerp in 1822 by a consortium of London dealers and sold to Peel two years later for the huge price of £2725. Peel rightly considered it to be one of the most important works in his distinguished collection of Dutch and Flemish paintings and paid tribute to it by commissioning Sir Thomas Lawrence to paint his wife, Lady Julia Peel, in the same format, pose and dress.

In more recent years the Flemish collection has continued to grow and in fact four of the paintings in this book were purchased during the last decade, three van Dycks under private treaty sale arrangements and one Rubens, the monumental *Samson and Delilah* (Plate 3), at auction in London in 1980.

PLATE 1

Jan Brueghel the Elder (1568–1625)

The Adoration of the Kings

Signed and dated: (.) RUEGHEL in 1598
Bodycolour on vellum, 32.9 × 48 cm.
Presented by Alfred A. de Pass, 1920

This small picture on vellum is the only example in the National Gallery of the modest, meticulous and yet extremely influential art of Jan Brueghel the Elder. He was the second son of Pieter Bruegel the Elder, the great painter of landscapes and peasant life, and was himself the father of painters. This work represents two aspects of Jan Brueghel's artistic inheritance: the technique of applying bodycolour – a kind of water-colour strengthened with gouache – to vellum was said to have been taught to the young artist by his grandmother, while the composition has strong echoes of his father's paintings of the same subject. Pieter Bruegel's *Adoration of the Kings* which is now in Brussels is undoubtedly the basis of his son's lay-out of the principal elements, while the poses of Balthazar, the Moorish king, Saint Joseph and the man talking to him, as well as the helmeted soldier in the centre looking down at Jesus, are taken from Pieter Bruegel's *Adoration* in the National Gallery. Jan Brueghel had also studied other Netherlandish predecessors: the tumbledown cottage, the figures crowding its doorway and the king kneeling directly in front of Jesus are derived from Hieronymus Bosch's interpretation of the subject which is today in the Prado Museum in Madrid.

What is strikingly individual about Jan Brueghel's painting is the fine, almost miniaturistic technique and – a consequence of the first – the proliferation of detail. The Biblical accounts say nothing of a large crowd, but Jan Brueghel has included so many onlookers that the figures of the kings themselves are almost lost. A group of shepherds are included to the right of Balthazar, so referring to their worship of the Child. There are many telling details like the pile of Joseph's wood-working tools in the lower right corner. The whole scene, rather than taking place in Bethlehem, is given a contemporary setting. Beyond the dilapidated hut – a symbol of the Old Law of Moses which is to be replaced by that of Christ – is a view of a sizeable Flemish town. A number of buildings – the two churches and the tower beside the bridge – stand out but are difficult to identify precisely. They are probably imaginary, although based on particular buildings: the tower, for example, is similar to the Roodepoorte in Antwerp, a fourteenth-century building which was demolished in 1865.

This was clearly a very successful composition as Jan Brueghel painted at least four other versions of it; they are all painted in oil on copper panels.

PLATE 2

Peter Paul Rubens (1577–1640)

Paris awards the Golden Apple to Venus ("The Judgement of Paris")

Wood (oak), 133.9 × 174.5 cm.
Purchased, 1966

This is the earliest painting by Rubens in the National Gallery. It was painted in about 1600, either just before the artist left Antwerp on his way to Italy or shortly after he arrived there. The composition is based on an engraving from the school of Raphael, which would have been available to him in Antwerp, but it is striking that the putti in the sky, one of whom crowns the victorious Venus, are very similar to figures by Rubens' master, Otto van Veen. The distant landscape is also derivative, being very much in the style of the Antwerp school of landscape painters.

Rubens shows the moment at which the shepherd Paris, who is in fact a Prince of Troy, hands the golden apple marked "to the fairest" to Venus. Juno, on her right, expresses her anger at the choice. Minerva, who is identified by the pile of armour at her feet, has turned her back on Paris and on the spectator. This subject was particularly favoured by Renaissance and Baroque painters because it gave them the opportunity to paint three female nudes. Rubens returned to it on a number of occasions, most memorably in the second version in the National Gallery (Plate 17). That interpretation, painted about thirty-five years after this picture, is far more subtle not only in the treatment of textures, facial expressions and pose but in its story-telling. There Rubens points forward to the tragic consequences of Paris' choice – the Trojan war.

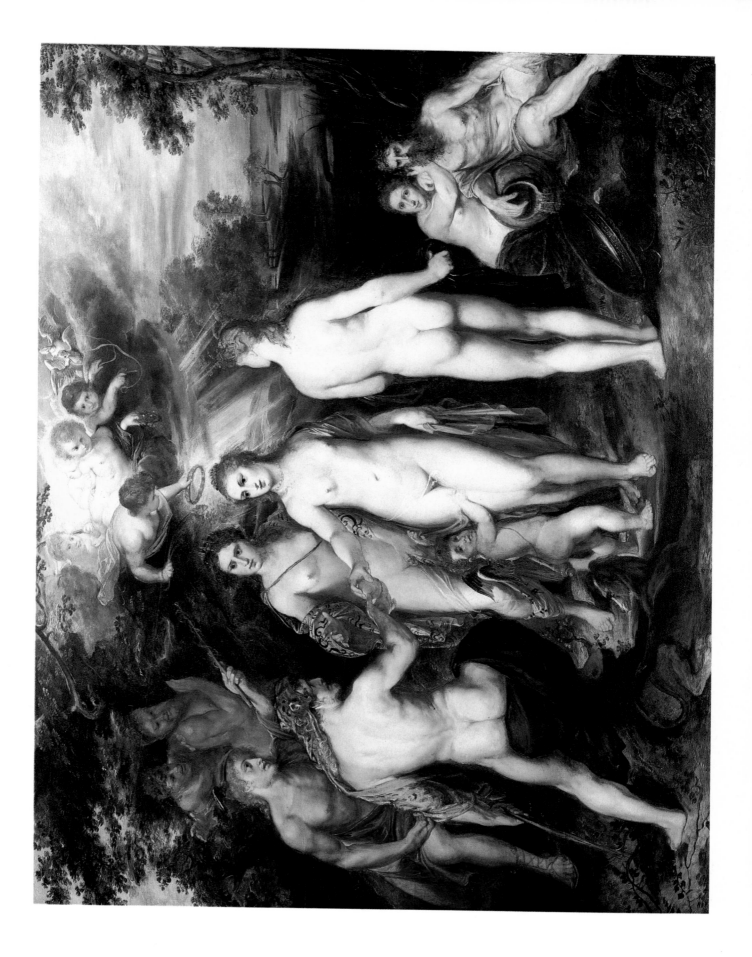

PLATE 3

Peter Paul Rubens (1577–1640)

Samson and Delilah

Wood (oak), 185 × 205 cm.
Purchased, 1980

This large-scale, powerful and erotic picture was painted by Rubens shortly after his return from Italy in 1608. The extent of the transformation which his eight-year stay brought about in Rubens' work is evident if one compares this superbly accomplished painting with the derivative "*Judgement of Paris*" (Plate 2) of about 1600, *Samson and Delilah* was painted, probably in 1609, for Nicolaas Rockox, burgomaster of Antwerp and one of Rubens' most influential patrons in the years immediately following his return from Italy. The painting was to hang in the "great salon" (*'t Groot Saleth*) of Rockox's house in Antwerp. Its presence there is recorded in a painting by Frans Francken the Younger, now in the Alte Pinakothek in Munich. As Rockox entertained the leading citizens of Antwerp in this room, the painting would be a prominent advertisement of Rubens' skills. He took great trouble in working out the composition – a preparatory pen drawing and an oil sketch or *modello*, which would have been shown to Rockox, survive. Once, however, Rubens was satisfied with the composition he worked swiftly: the paint is thinly and broadly brushed onto the panel with rapid, confident strokes.

Rubens shows the moment in the story of the great Jewish hero when one of the Philistines nervously begins to cut Samson's hair, the source of his strength, as he sleeps in Delilah's lap. The other Philistines crowd apprehensively into the doorway.

Memories of works which Rubens had studied in Italy are present throughout. His study of the antique and of Michelangelo is clearly reflected in Samson's superbly muscled back and arms.

Michelangelo's *Night* in the Medici Chapel of San Lorenzo in Florence inspired the pose of Delilah, and the use of three distinct light sources recalls Caravaggio. The composition as a whole owes much to the work of the German painter Adam Elsheimer, who had settled in Rome: it almost seems to be one of Elsheimer's small copper panels expanded to a monumental scale. However, while it is possible to identify Rubens' debts to other artists, *Samson and Delilah* is in no sense derivative. Rubens draws strength from his profound understanding of Michelangelo and Elsheimer, interpreting and reinterpreting features of their work in such a way that an entirely original and independent work of art is created. There can be no doubt that the thirty-three-year-old painter had found his quite individual artistic personality: the monumental composition, the profound treatment of Delilah, whose face and gesture with the left hand convey both triumph and pity, the confident application of paint, the rich, saturated colours, the choice of a highly dramatic moment in the story, the eroticism – all were to continue to be features of Rubens' mature art.

Samson and Delilah was sold by Rockox's heirs to the Antwerp art dealer Guillaum Forchoudt, who in turn sold it to the Prince of Liechtenstein. It was in the Liechtenstein palace in Vienna by 1700. It was sold from that collection in 1880 and, after some years of obscurity, was rediscovered in Paris in 1929. In the following year it was sold to the Hamburg tobacco magnate, August Neuerburg, whose family sent it for sale in London in 1980. It was purchased at auction by the National Gallery.

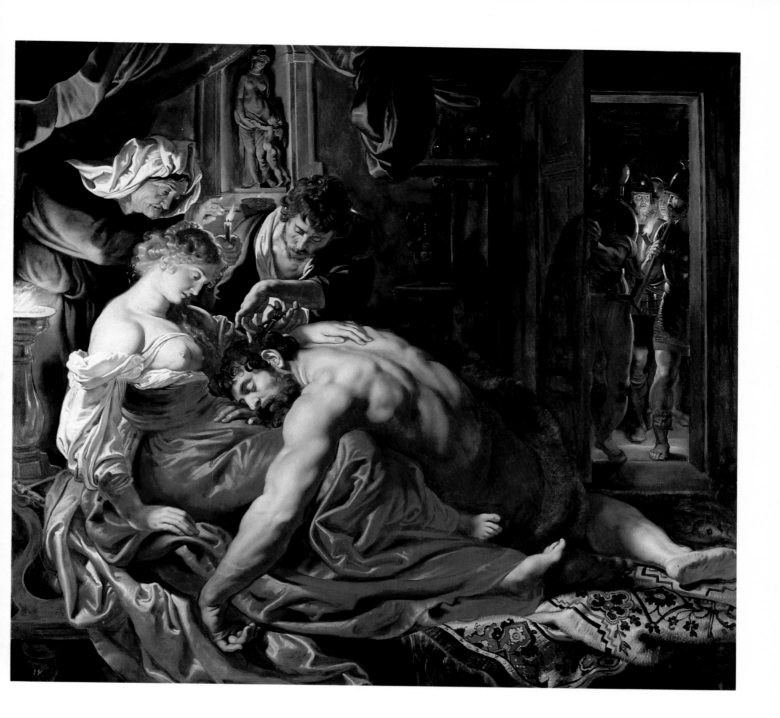

PLATE 4

Peter Paul Rubens (1577–1640)

Saint Bavo about to receive the Monastic Habit at Ghent

Wood (oak), centre panel approximately 106.7 × 82.1 cm.; side panels approximately 107.6 × 41.1 cm.
Holwell Carr Bequest, 1831

This is an oil sketch or *modello* for a triptych which was to stand on the high altar of the church of St Bavo in Ghent. It had been commissioned from Rubens by Bishop Maes of Ghent in 1611 or 1612. The bishop died, however, in May 1612 and his successor abandoned the idea of a painted altarpiece, preferring a sculpted one. In 1614 Rubens asked the Archduke Albert to intercede with the bishop on his behalf, especially as, he said in a letter, it was the most beautiful thing he had ever done. There can be no doubt that Rubens put great care and effort into the design of this altarpiece, one of the most important commissions he had received since his return home from Italy in 1608. In particular he would have been very conscious that St Bavo's contained the greatest single painting by one of his Flemish predecessors: Jan van Eyck's Ghent altarpiece. Rubens' pleading fell, however, on deaf ears and a contract for a sculpted altarpiece was signed by the Bishop of Ghent with the brothers Robert and Jan de Nole in 1615. Later a new contract drawn up by Bishop Antoine Triest in 1623 with Robert de Nole specified a painting at the centre of the altar, so reverting to some extent to the original plan. This commission was given to Rubens but the shape of the altarpiece was quite different and his own art had undergone major changes since the first commission for St Bavo's. He therefore painted a new composition, although he did incorporate individual figures from the *modello*; this large canvas hangs today in a side chapel in St Bavo's.

Rubens took his account of Saint Bavo from J. Molanus' *Indiculus Sanctorum Belgii* which had been published in Louvain in 1573. The saint, who died in 653, is shown entering the Benedictine monastery of St Peter's in Ghent. In the central panel of Rubens' *modello* Count Allowin of Haspengouw, having decided to abandon his career as a soldier, is standing on the steps of the monastery. He is greeted by the abbot, Saint Floribert, who bends forward towards him, and by Saint Amandus, the Bishop of Tongres, who had been responsible for his conversion. The count, the future Saint Bavo, has placed his coronet at the bishop's feet. His wealth is being distributed to the poor in the left-hand corner. The women on the left-hand wing are Saint Gertrude, who is removing her necklace, and her sister Saint Begga, relatives of Saint Bavo, who themselves both entered monasteries. On the right wing are Kings Clothar and Dagobert, father and son, who supported Saint Bavo in his decision to become a monk. They refused to accept the imperial edict, here presented to them by a messenger wearing the imperial eagle on his tunic, that forbade knights to enter a monastery.

It is a matter of great regret that this ambitious and effective composition, which links the three scenes by the use of continuous architecture and the group of poor people at the bottom left, was not carried out on a larger scale.

The *modello* was presumably still in Rubens' studio in 1623 when he painted the new altarpiece for St Bavo's. It is next recorded in Genoa in 1758 and was bought there on behalf of the Rev. Holwell Carr in 1805. Holwell Carr bequeathed it to the National Gallery in 1831.

PLATE 5

Peter Paul Rubens (1577–1640)

A Lion Hunt

Grisaille on wood (oak), approximately 73.6 × 105.4 cm.
Purchased with the Peel collection, 1871

Rubens painted a number of large scenes of animal hunts – lions, tigers, wolves, wild boar, even a crocodile. Such paintings were much in demand among members of the aristocracy, for whom hunting was the principal form of recreation. Both the Duke of Bavaria and the Duke of Buckingham, for example, owned paintings of lion hunts by Rubens. For Rubens, hunting scenes presented intriguing problems of composition and of the representation of highly dramatic situations. They involved the depiction of both animal and human fear as well as attitudes of determination and triumph.

This painting is a sketch, drawn with the brush in brown paint on a prepared, tawny-coloured panel. Highlights have been added in white paint. In it Rubens is experimenting with the central group of a terrified rider being pulled from his horse by a lion while two men with lances, and another on the right with a sword, try to dislodge the lion. Rubens has repeated the rider and the lion in a slightly altered pose in the top right-hand corner. Rubens incorporated this group – though without the two men wielding lances on the left – in a large canvas of a lion hunt which today is in the Alte Pinakothek in Munich.

During his years in Italy Rubens had travelled extensively in the peninsula, studying the Antique, as well as Renaissance and contemporary painting. Among the artists whose work was of particular interest to him was Leonardo da Vinci. Leonardo's great fresco of *The Battle of Anghiari* had long since faded on its wall in the Palazzo Vecchio in Florence and been painted over by Giorgio Vasari, but Rubens made a fine painted copy of the central part of it, *The Battle for the Standard*, working from an engraving or a painted copy. In 1616/17 he used the composition of *The Battle for the Standard* for the central group in this sketch. It is an example of the certain way in which Rubens made use of Italian models, often employing motifs in a quite different context from that of the original.

This sketch was purchased by Sir Robert Peel from the London dealer John Smith in 1826 for 100 guineas. It came to the National Gallery with the rest of the Peel collection in 1871.

PLATE 6

Peter Paul Rubens (1577–1640)

The Miraculous Draught of Fishes

Pencil, pen and oil on paper, stuck on canvas, approximately 54.5 × 84.5 cm.
Purchased, 1861

The miracle is described in Luke, chapter 5, verses 1–10. Jesus went out in Simon Peter's fishing boat onto the lake of Gennesaret. He told him to cast out his nets but Simon Peter protested that he had been fishing all night without success. When he pulled the nets up they broke beneath the weight of the fish they contained. Simon Peter was ashamed that he had questioned Jesus' instruction, but Jesus replied, "Fear not; from henceforth thou shalt catch men".

Rubens received the commission to paint a triptych for the church of Notre Dame au delà de la Dyle, Malines, of which the central panel was to show the Miraculous Draught of Fishes, in October 1617. The painting was completed two years later, and its composition is based on Raphael's treatment of the subject in his tapestry cartoon, now in the Victoria and Albert Museum. This sketch or *modello*, executed on paper in a combination of pencil, pen and oil paint, is preparatory to an engraving made of the composition of the triptych's central panel by Schelte a Bolswert, an Antwerp engraver who often worked for Rubens. Although it is not dated, Bolswert's engraving has an inscription recording that it was issued with the joint "privilege" (authorisation) of the Archduke Albert and Archduchess Isabella, the regents of the southern Netherlands for the King of Spain. Albert died in 1621, so the engraving (and its *modello*) must have been made between the completion of the altarpiece in August 1619 and Albert's death.

Rubens, an astute businessman, was very conscious of the commercial possibilities of his work and many of his paintings were reproduced in the form of engravings which would be sold widely. He exercised a close personal supervision over the production of these engravings, as is clear from the care that he took with this *modello*. If it is compared with the painting still in the church in Malines it can be seen that Rubens has made a number of minor alterations, such as the exact poses of Simon Peter and Christ and the position of the horizon, which improve the composition for the purposes of an engraving. The painting, in black, brown and grey with white highlights, possesses all the immediacy and vigour that we expect of Rubens' working sketches.

PLATE 7

Peter Paul Rubens (1577–1640)

The "Coup de Lance"

Mainly grisaille on wood (oak), 64.8 × 49.9 cm.
On loan from the Victoria and Albert Museum since 1895

This is a sketch, in brown and black paint with white highlights, for the high altarpiece in the church of the Récollets (*Minderbroeder*) in Antwerp. Today the altarpiece is in the Museum voor Schone Kunsten in Antwerp. The altarpiece was paid for by Rubens' important early patron, Nicolaas Rockox, for whom the artist painted the *Samson and Delilah* (Plate 3), and it was installed in the church in 1620. This sketch presumably dates from the previous year.

It is first recorded in the monastery of the Récollets in Antwerp, which suggests that it was Rubens' first general scheme for the altarpiece, to be shown to the monks to give them an idea of the composition he had in mind. As there are significant differences between this sketch and the finished altarpiece it cannot have been the final *modello* executed for the studio to follow. There are also a number of drawings for this major commission which show Rubens moving closer to the definitive version of the composition.

The painting is recorded in the collection of the monastery in 1753. The order was suppressed in 1794 and the sketch sold in that year to a Ghent collector. It was bought by the London dealer John Smith at a sale in Belgium in 1840. He sold it to George Mitchell, who bequeathed it to the South Kensington Museum (now the Victoria and Albert Museum) in 1878. It was placed on loan in the National Gallery in 1895.

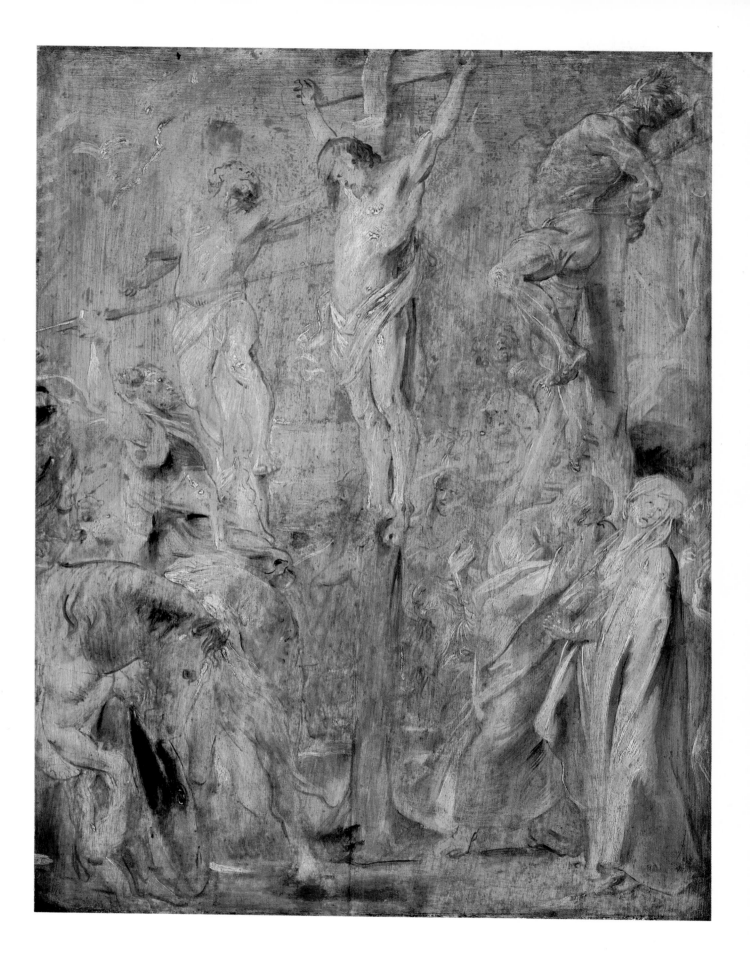

PLATE 8

Peter Paul Rubens (1577–1640)

Peasants with Cattle by a Stream in a Woody Landscape ("The Watering Place")

Black chalk and oil on wood (oak), approximately 98.7 × 135 cm.
Purchased with a contribution from the National Art-Collections Fund, 1936

"*The Watering Place*" is the name by which this outstanding landscape by Rubens has become known. It is very difficult to date Rubens' landscapes with any accuracy but this one is thought to have been painted at some point between 1615 and 1622. The physical construction of the painting is extremely complex. The core of the picture is a rectangle on the left side showing a flock of sheep grazing on a path which winds alongside the river. The composition is strikingly similar to another Rubens landscape in the National Gallery (Plate 9). Apparently Rubens enlarged this composition by asking a panel-maker to add pieces of wood to the original panel. He painted out the original shepherd (who can be seen in infra-red photographs), creating a new group of cattle and figures in the foreground. He expanded the landscape at both sides, closing the composition on the left with a group of trees outlined against the sky and on the right with a rocky gorge.

Rubens' landscapes were much admired in England in the eighteenth and nineteenth centuries. Horace Walpole wrote that Rubens "was never greater than in landscape". This particular painting was in the collection of the 3rd Duke of Montagu by 1768 when it was seen by Gainsborough, who wrote to Garrick that summer: "I could wish you to call *upon any pretence* at the Duke of Montagu . . . not as if you thought anything of mine worth that trouble, only to see his Grace's landskip of Rubens . . .". Gainsborough's own landscape style was profoundly affected by his study of Rubens and in the English painter's own *Watering Place*, which is also in the National Gallery, he painted a tribute to the Flemish master. Walpole thought Gainsborough's painting, which was exhibited at the Royal Academy in 1777, "in the style of Rubens, and by far the finest landscape ever painted in England, and equal to the great Masters". Hazlitt, however, was later to castigate Gainsborough for his "flimsy caricatures of Rubens".

The 3rd Duke of Montagu's daughter, Elizabeth, inherited the painting. She married the 3rd Duke of Buccleuch, whose descendant, the 8th Duke, sold it to the National Gallery in 1936.

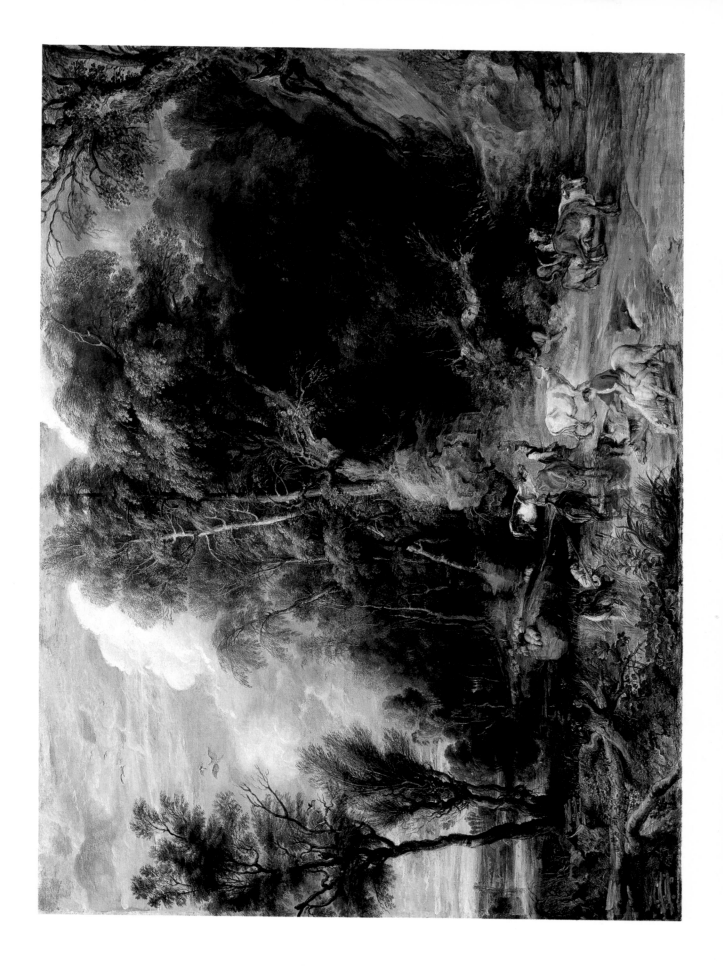

PLATE 9

Peter Paul Rubens (1577–1640)

A Shepherd with his Flock in a Woody Landscape

Wood (oak), approximately 63.9 × 94.3 cm.
Presented by Rosalind, Countess of Carlisle, 1913

It is very difficult to place Rubens' landscapes within the general chronology of his work. Many of his landscapes, like the *Autumn Landscape with a View of Het Steen* (Plate 18), date from the last decade of his life when he came to spend more and more time with his young family at his country house. This picture, however, and the other landscape in the National Gallery to which it is closely related, the so-called *"Watering Place"* (Plate 8), are usually believed to have been painted earlier in his career, probably between 1615 and 1622. Rubens used the composition of this painting as the basis of that in the far more complex *"Watering Place"*.

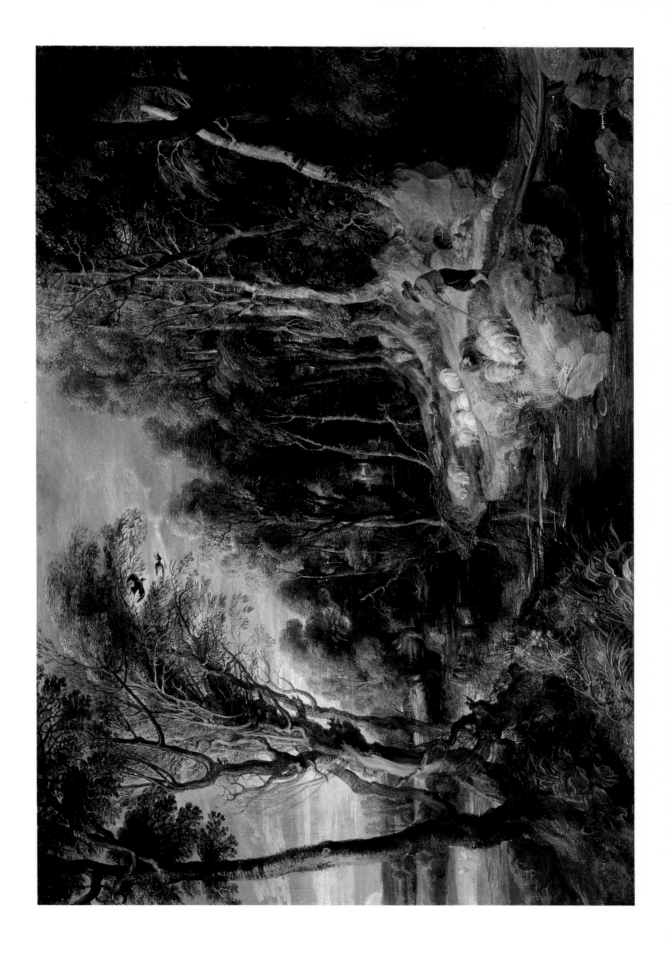

PLATE 10

Peter Paul Rubens (1577–1640)

Portrait of Susanna Lunden (?) ("Le Chapeau de Paille")

Wood (oak), approximately 79 × 54 cm.
Purchased with the Peel collection, 1871

Susanna Fourment (1599–1643) was the third daughter of Daniel Fourment, a wealthy Antwerp silk merchant whom Rubens had known well for a number of years and for whom he had designed a series of tapestries showing scenes from the life of Ulysses. Susanna married Raymond del Monte in 1617 but was widowed shortly after. In 1622 she married for a second time: her husband was Arnold Lunden. Here she seems to be in her early twenties and wears what may be a betrothal or wedding ring, so the painting probably dates from the time of her marriage to Lunden.

The portrait was identified as Susanna Lunden as early as 1753, and this identification, which has been widely accepted, accounts for the strong family likeness to Rubens' second wife. In 1630 Rubens, who had been a widower for four years, married again: his bride was Susanna's youngest sister, the sixteen-year-old Hélène Fourment.

For almost two hundred years the painting has been known as the "Chapeau de Paille". Why a portrait of a young woman wearing what is clearly a felt hat decorated with feathers should come to be known as "The Straw Hat" is unclear, but it may have been confused with another painting owned by the Lunden family in the late eighteenth century. The hat is of a type worn by both men and women in the Netherlands in the 1620s.

Thus, the painting was seen and admired in Antwerp, still in the collection of a member of the Lunden family, by Sir Joshua Reynolds in 1781. It was bought by a consortium of London dealers in 1822 and then by Sir Robert Peel in 1824 for £2725. When Sir Thomas Lawrence painted Peel's wife, Lady Julia, in 1827, he based the composition on Rubens' famous portrait; it may even have been intended as a pendant to the Rubens. (Lawrence's portrait of Lady Peel is today in the Frick Collection in New York.) It was purchased by the National Gallery with the Peel collection in 1871.

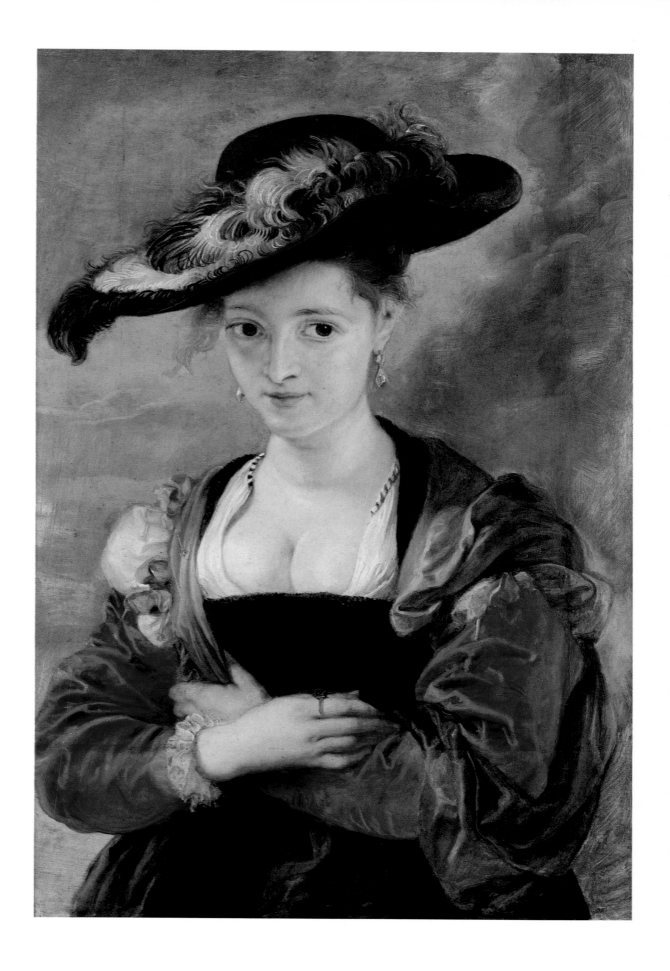

PLATE 11

Peter Paul Rubens (1577–1640)

Minerva and Mercury conduct the Duke of Buckingham to the Temple of Virtue (?)

Wood (oak), painted area roughly circular, 62 × 62.5 cm.
Purchased, 1843

George Villiers (1592–1628), the favourite of James I from 1617 and subsequently of his son Charles I, was made 1st Duke of Buckingham in 1623. In 1625 he was created General of the Army and of the Fleet, but his career came to a violent end when he was assassinated in Portsmouth in 1628.

Buckingham, who was an important collector of contemporary and Renaissance art as well as antiquities, met Rubens for the first time in Paris in 1625, and it was either on that occasion, or shortly after, that the duke commissioned from the artist a ceiling painting for which this is an oil sketch. The ceiling painting, which hung in Buckingham's London residence, York House, has been destroyed and the sketch survives as the only record of this important project. Buckingham chose to have himself portrayed being carried aloft by Minerva, goddess of wisdom, who is helmeted and carries a shield, and Mercury, god of eloquence, who crowns the duke with a laurel wreath. Another wreath is proffered by the Three Graces who represent the joyful life. The woman with snakes in her hair, who tries to pull the duke down, is Envy. She does not, however, slow his ascent to the temple where the figure of Virtue waits to greet him. In allegorical form the composition is an expression of Buckingham's aims and aspirations, and of the envious forces that tried to prevent him from attaining them. These allegorical figures had their counterparts in real life: there were constant calls for the duke's impeachment at this time, particularly on the grounds of military incompetence.

This oil sketch would have been shown to the duke. He apparently requested some changes of detail as the finished ceiling, while the subject is the same, showed a number of differences in the arrangement of the figures. The ceiling seems to have arrived in England from Rubens' Antwerp studio only a few months before the duke's assassination.

In designing this secular assumption Rubens took his inspiration from the *Ascent of Christ* painted by Correggio in the dome of San Giovanni Evangelista in Parma which Rubens had seen during his years in Italy. And having created such an effective composition Rubens returned to it later in his career. The same essential organisation of figures can be found in the *Apotheosis of James I* in the Banqueting House, which was painted for Charles I more than ten years later.

This sketch was owned by the painter Sir David Wilkie and was included in the sale of his effects in 1842, the year after his death. It was later purchased by the National Gallery for £200.

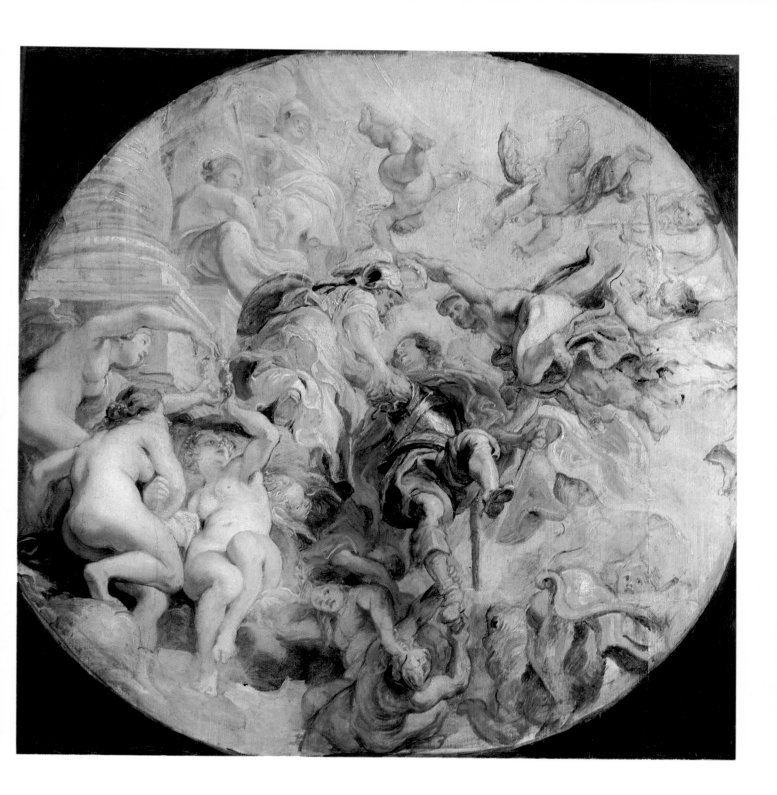

PLATE 12

Peter Paul Rubens (1577–1640)

Portrait of Ludovicus Nonnius

Wood, 124.4 × 92.2 cm.
Purchased, 1970

Ludovicus Nonnius (around 1553–1645/6) was a doctor of Portuguese extraction who lived in Antwerp. He was the author of a number of books including a famous treatise on diet, the *Diaeteticon*, published in 1627. This lively portrait dates from the late 1620s, perhaps from the very year of the publication of Nonnius' most important book. Nonnius' head is framed by an empty niche as if his bust is in time to be placed in such an honoured place. On the left is a marble head – so animated by Rubens that it seems no less human than Nonnius himself – of Hippocrates, the Greek founder of medicine. On the right is a fluently painted still life of books. The book which Nonnius himself holds, perhaps the *Diaeteticon*, gives the illusion of being about to tumble out of the picture. Above all, the painting conveys a sense of intellectual excitement, the excitement of the rediscovery of antiquity and of scientific progress.

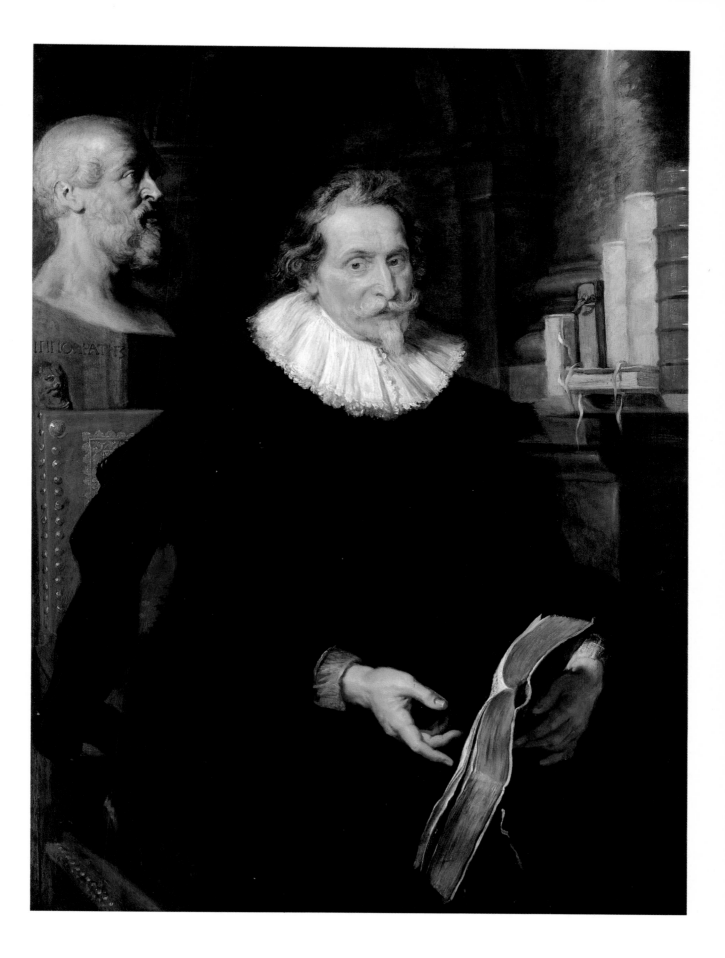

PLATE 13

Peter Paul Rubens (1577–1640)

Portrait of Thomas Howard, 2nd Earl of Arundel

Canvas, 67 × 54 cm.

Presented by Rosalind, Countess of Carlisle, 1914

Thomas Howard, 2nd Earl of Arundel (1585–1646), was a great collector and patron of the arts whom Rubens met while in England in 1629 and 1630. Rubens described Arundel as "an evangelist for the world of art and the great protector of our state". This portrait was probably painted during Rubens' stay in England. Sir Robert Walker, who accompanied Arundel on his mission on behalf of the king to Ratisbon (Regensberg) in 1636, described the earl's appearance at that time: "He was tall of Stature, and of Shape and proportion rather goodly than neat; his Countenance was majestical and grave, his Visage long, his Eyes large black and piercing; he had a hooked Nose, and some Warts or Moles on his cheeks; his countenance was brown, his hair thin both on his Head and Beard". All these features can be observed in Rubens' portrait, but above all the picture conveys strength and firmness of purpose as well as the ancient nobility of which Arundel was so inordinately proud.

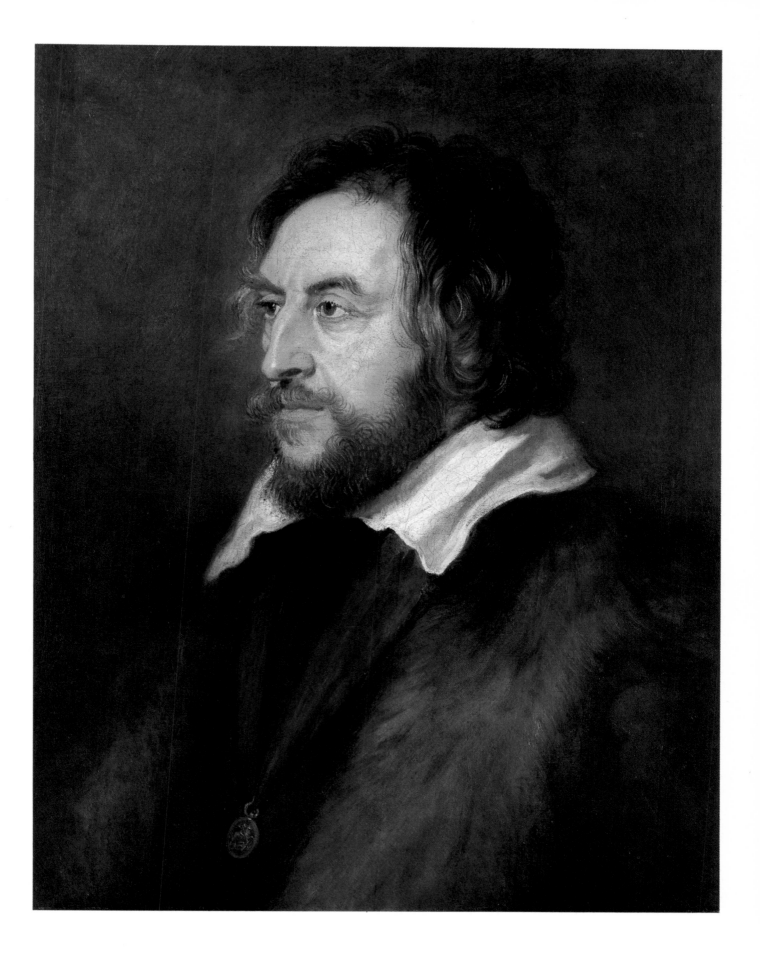

PLATE 14

Peter Paul Rubens (1577–1640)

Minerva protects Pax from Mars ("Peace and War")

Canvas, approximately 203.5 × 298 cm.
Presented by the Duke of Sutherland, 1828

In 1629 Rubens came to England in the capacity of a diplomat in the service of King Philip IV of Spain. Rubens' native Flanders was part of the Spanish empire which was at war with the United Provinces (the modern Netherlands) and the purpose of Spanish diplomacy at that moment was to secure the neutrality of England in the war. Rubens' purpose, which was soon achieved, was to arrange for an exchange of ambassadors who were to negotiate a peace treaty between England and Spain. Rubens remained in England for almost a year and it was during his stay that he painted this great allegorical canvas for the king, Charles I. In the catalogue of Charles's paintings, compiled by Abraham van der Doort, the Keeper of the Royal Collection, it is described as: "Done by Sir Peeter Paule Rubens Item A Picture of an Emblin wherein the differrencs and ensuencees between peace and warrs is shewed which Sir Peeter Paule Rubins when he was here in England did paint and Was presented by him to *ju* M. [Your Majesty] Wij Conteys some 9 ffigures".

The painting sets forth in pictorial terms the diplomatic aims of Rubens' mission to England. In the centre is the figure of Peace (Pax) pressing milk from her breast to feed the child Plutus, the god of wealth. Peace is protected by the heavily-armoured figure of Minerva, goddess of wisdom and the arts, who forces away Mars, the god of war, and behind him the fury Alecto. Meanwhile, at the extreme right, a screaming phantom spitting fire hovers over the scene. War is shown in this way to be an ever-present threat, always poised to disrupt peace. In the foreground three children are led forward by a winged cupid and the torch-carrying boy-god of marriage, Hymen, to enjoy the fruits of peace which spill forth from a cornucopia held out by a satyr, who is associated with feasting, drinking and love. Marriage and prosperity are here shown as consequences of peace. On the left a woman brings wealth in the form of precious objects and jewels. Beside her another woman joyfully shakes a tambourine. Even the leopard is shown to be merely playful, rolling on his back to claw at the vine leaves on the grapes. Above the head of Pax a winged putto (naked child) holds an olive wreath and a caduceus (the attribute of Mercury, messenger of the gods), both symbols of peace. Though the form that the allegory takes may seem obscure to modern eyes, its message is simple: Peace brings prosperity, stable family life and general happiness. It must be vigorously protected from the constant threat of war.

The models for the heads of Hymen and the two girls being led towards him were the three eldest children – George, Elizabeth and Susan – of Sir Balthasar Gerbier, Rubens' host during his stay in England. Portrait drawings of the children made from life survive today.

When Charles I's collection was sold after his death *"Peace and War"* found its way to Italy, where it is first recorded in the Palazzo Giorgio Doria in Genoa in 1768. In 1802 it was purchased in Genoa on behalf of the English dealer William Buchanan, from whom it was bought by the future Duke of Sutherland in the following year for £3000. He presented it to the National Gallery in 1828.

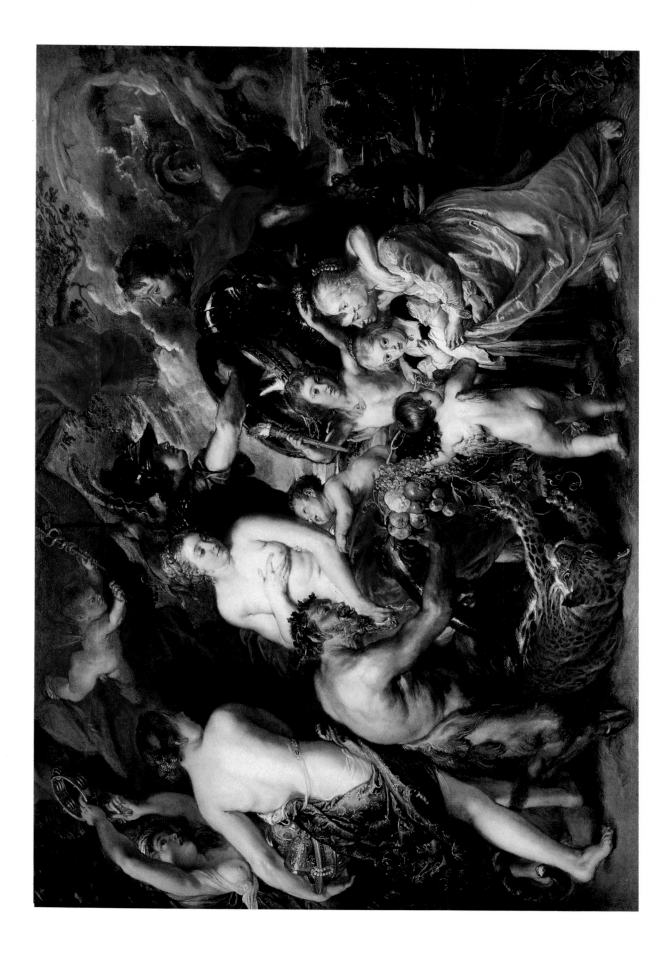

PLATE 15

Peter Paul Rubens (1577–1640)

A Roman Triumph

Canvas, 86.8 × 163.9 cm.
Purchased, 1856

Shortly after his arrival in Italy in 1600, Rubens entered the service of the Gonzaga family in Mantua as a court painter. One of his predecessors as court painter in Mantua was the great Renaissance artist Andrea Mantegna, who had served the Gonzaga from about 1460 until his death in 1506. Mantegna had executed for his patrons a series of nine large canvases depicting the triumph of Julius Caesar when he returned to Rome from his conquest of Gaul. During his years in Mantua Rubens must have come to know Mantegna's series very well. Indeed, Mantegna was the only fifteenth-century Italian artist in whom Rubens took a significant interest, since he shared Rubens' almost archaeological passion for the classical past.

Mantegna's *Triumph of Julius Caesar* re-entered Rubens' life long after he had returned from Italy to Antwerp in 1608. Many of the greatest treasures of the Gonzaga collection, including the Mantegna series, were sold by the Duke of Mantua to Charles I. The paintings themselves seem to have arrived in England in 1630 or shortly after. Rubens, who deplored the break up of the great Mantua collection, was on a diplomatic mission to England in 1629 and 1630, when the English court was humming with excitement at the prospect of the imminent arrival of the Mantua treasures. It was presumably this interest that caused Rubens to look again at the woodcuts of the series made by Andrea Andreani and subsequently to paint this free copy of two of the scenes.

A careful comparison with the woodcuts or indeed with the original canvases – now displayed in the Orangery at Hampton Court Palace – reveal the extent to which Rubens' painting is a creative interpretation of Mantegna's original designs. The right-hand side does follow the fifth of Mantegna's canvases quite closely in its general composition and in the disposition of the principal figures, but the positions of the elephants' heads have, for example, been altered. Moving towards the left, the central figure of a bearded priest is an invention of Rubens as are many of the figures on the left-hand side. The figures and the architecture in the background are entirely invented by Rubens. Rubens seems to have painted free copies of two of Mantegna's scenes, the fourth and fifth in the series; he then pasted his two canvases down onto a panel and inserted the central figure and the background in order to unite the two halves into a single, effective composition. Rubens' most remarkable achievement is, however, one of mood rather than design. He has infused Mantegna's austere, even dry, classicism with a vigorous, almost earthy, Flemish naturalism. This is no archaeological curiosity: it is a real world of men and animals.

The painting was sent in 1673 from Antwerp by the art dealer Forchoudt to Vienna, where his sons had opened a branch of the business. It may have been bought in Vienna by Costantino Balbi, who was Genoese ambassador there from 1706 to 1710. It was certainly in Genoa by 1758 and was sold to the British dealer William Buchanan in 1802. It was subsequently owned by the poet Samuel Rogers and was acquired after his death at a sale of his collection in 1856 by the National Gallery for 1050 guineas.

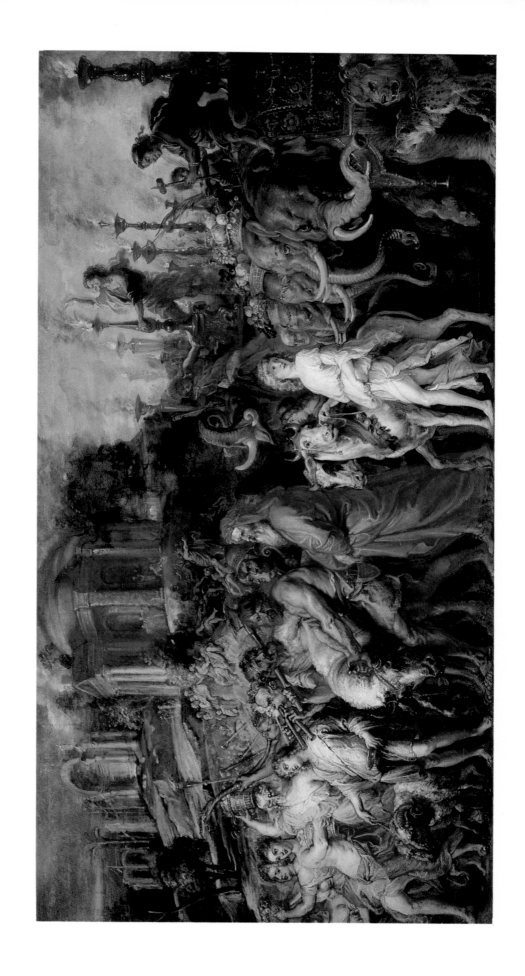

PLATE 16

Peter Paul Rubens (1577–1640)

The Birth of Venus

Black chalk and grisaille on wood (oak), 61 × 78 cm.
Purchased, 1885

Rubens was a versatile artist. As well as being a painter and directing a large studio, he designed tapestries, book illustrations and ornate tableware. He even designed an ivory salt-cellar. This is the sketch for a basin which, with its accompanying ewer (the design for which does not survive), was conceived by Rubens for Charles I and cast in silver by Theodore Rogiers, an Antwerp silver-smith. The identification is taken from a print made around 1660 by Jacob Neeffs showing both basin and ewer. There is no other record of the vessels ever having been cast. The work probably dates from about 1630, that is shortly after Rubens' return to Antwerp after his stay in England.

The subject, as we should expect of the work of an artist of Rubens' sophistication, is entirely appropriate to the vessel's function. It shows the Birth of Venus: the goddess is seen stepping from her shell onto the island of Cyprus. She is assisted by three female attendants or Nereids. Venus wrings the foam from her hair with her right hand. She is being crowned by Cupid and a female figure representing Persuasion. Another woman follows behind, riding on a Triton and blowing a conch shell: she is probably a personification of Desire. The two figures at the top of the outer rim are Neptune, the god of the sea from which Venus has risen, and Amphitrite, his wife. The embracing figures at the bottom are Cupid and Psyche. The design would have been embossed so Venus would gradually be revealed as the basin was drained. The accompanying ewer had as its principal subject the Judgement of Paris, in which Venus receives the golden apple from Paris.

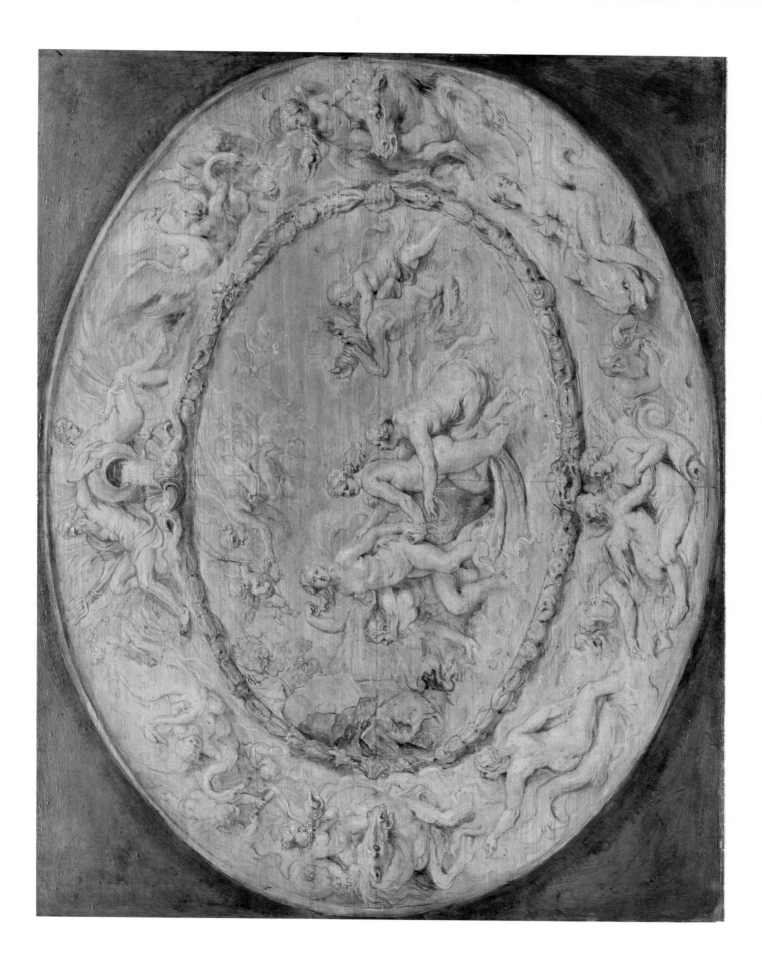

PLATE 17

Peter Paul Rubens (1577–1640)

Paris awards the Golden Apple to Venus ("The Judgement of Paris")

Wood (oak), 144.8 × 193.7 cm.
Purchased, 1844

There are two treatments of this subject by Rubens in the National Gallery. This painting dates from about 1632–5. The other one (Plate 2) was painted about thirty years earlier, around 1600, when the young Rubens was about to leave Antwerp for Italy. The comparison is fascinating. The earlier picture takes its composition from a print from the school of Raphael and is painted in the characteristically "hot" flesh tones and rich landscape greens of the Antwerp school. While the vigour of the modelling reveals the skill of the young draughtsman, it is a derivative and immature work. The second "Judgement of Paris", by comparison, is one of the greatest mythological paintings of Rubens' maturity. The bland masks and identically proportioned bodies of the goddesses in the earlier painting have given way to three clearly differentiated individuals. Rubens' palette had long before abandoned the stridency of Antwerp for the lightness and warmth of the Venetians, and especially of Titian. Raphael's stylised, over-refined nudes are replaced by the plump, fleshy figures that Rubens so admired. Indeed, it has been suggested that the model for Venus may be Rubens' second wife, Hélène Fourment, whom he married in 1630 and painted incessantly in the last decade of his life.

The painting depicts the moment in the story when Paris offers the golden apple marked "to the fairest" to Venus. Paris, a prince of Troy who had been abandoned as a child and raised as a shepherd, was renowned for his beauty. He was chosen by Jupiter to decide which of the three goddesses – Juno, Minerva or Venus – was to receive the golden apple. Standing beside Paris is Mercury, Jupiter's messenger. Minerva, on the left, her shield decorated with the head of Medusa hanging from a tree and her owl perched beside it, promised Paris glory in war if she were chosen; Juno, on the right, with the peacock at her feet, offered him riches; while Venus, in the centre, said she would give him the most beautiful woman in the world as his wife. Paris disdained fame and wealth, choosing love. The consequences were catastrophic, for he chose Helen as the most beautiful woman and his abduction of her precipitated the Trojan war. The Fury of War, flaming torch in hand, passes over the landscape tingeing the peaceful countryside red. If we compare the three goddesses, Paris' judgement here seems to be an accolade to modesty and reserve, not qualities normally associated with Venus. In Rubens' painting the brazen Minerva or the ample Juno, the sensuousness of whose back is heightened by the fur wrap casually draped around it, seem equally deserving. Juno's peacock is certainly partisan, hissing at Paris' dog, a foretaste of the bitterness to come.

The painting has an extremely distinguished history. It was in the collection of the Duc de Richelieu by 1675 and is recorded in 1727 as being in the Palais Royal in Paris, the residence of the Duc d'Orléans. It was among the paintings bought from the Orléans collection in 1792 by a syndicate of English collectors and dealers. It was exhibited for sale in London in 1793, but eventually entered the private collection of one member of the syndicate, Lord Kinnaird. It was purchased by the National Gallery at auction in 1844 for 4000 guineas.

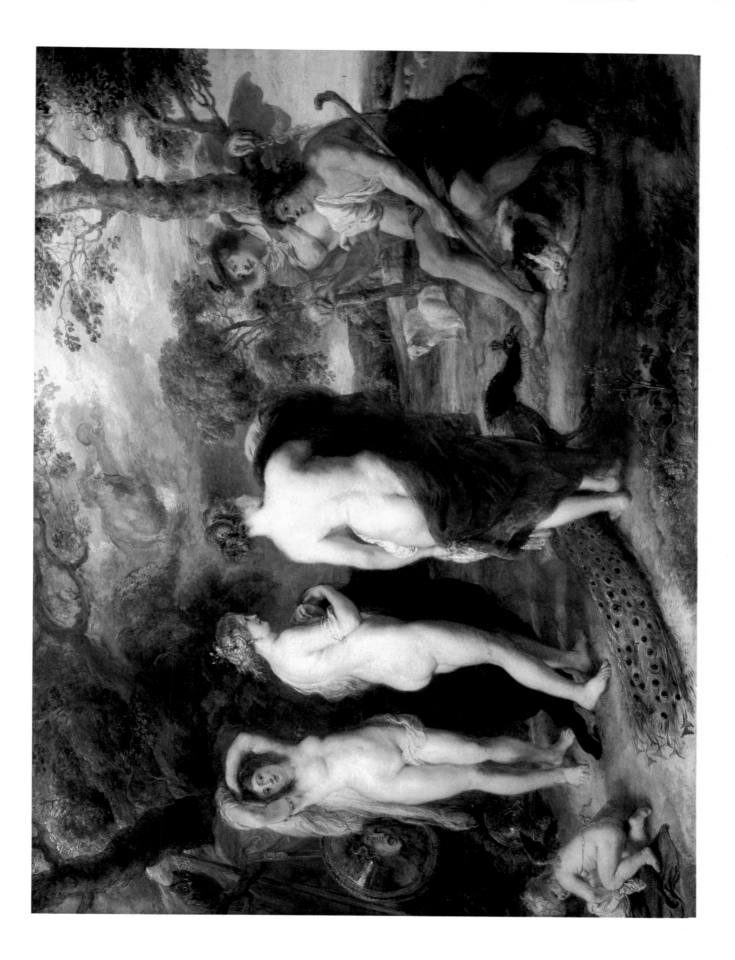

PLATE 18

Peter Paul Rubens (1577–1640)

An Autumn Landscape with a View of Het Steen in the Early Morning

Wood (oak), approximately 131.2 × 229.2 cm.

Promised by Sir George Beaumont for the proposed National Gallery, 1823; entered the Collection in 1828

Rubens' great success enabled him not only to buy a palatial residence in the centre of Antwerp but also a country house outside the city. In 1635, after his second marriage and with a young growing family, his country house became insufficient for his needs and he bought a new one – the castle of Het Steen near Elewijt between Vilvorde and Malines, the town that can be seen on the horizon in this picture. He probably painted this lyrical account of Het Steen and the surrounding country-side in the autumn of 1636. When it was put up for sale in 1682 it was described as "a manorial residence with a large stone house and other fine buildings in the form of a castle, with a garden, orchard, fruit trees and drawbridge, and a large hillock in the middle of which stands a high square tower, having also a lake and a farm ... the whole surrounded by moats". The tower and the exterior of the house, with its characteristically Flemish stepped gables, are clearly visible on the left of the picture. In the last five years of his life, often troubled by illness, Rubens came to spend more and more time at Het Steen. Not only did the artist take great pleasure in the estate itself, he also took great pride in the title – Lord of Steen – which went with it. It is prominently recorded on Rubens' tombstone in the Sint Jacobskerk in Antwerp.

Rubens has described the foreground in excep-tional detail. The partridges sunning themselves can be clearly identified, as can goldfinches, a kingfisher and two magpies. It can be seen that the season is autumn from the foreground flowers – a blackberry bush (partly in flower and partly bear-ing fruit), chrysanthemum, achillea and aretium, which are all autumn-flowering plants. The time of day is more difficult to establish, but if Rubens shows the position of the tower correctly, the sun is in the east and the time of day is early morning. The fully-loaded farm wagon would then be on its way to market, and the group of figures on the left setting out from the house for a walk.

The painting probably remained in Rubens' possession until his death and was among a group of landscapes sold by his family in Antwerp in 1640. It is next recorded in Genoa in 1758. In 1802 it was sold to an English art dealer, William Buchanan, who offered it to the British govern-ment and to J. J. Angerstein. In the event it was bought by Lady Beaumont in 1803 for her hus-band. While it was in Sir George Beaumont's possession it was seen, admired and copied by John Constable. It was presented by Sir George to the British Museum for the proposed National Gallery and transferred to the National Gallery in 1828.

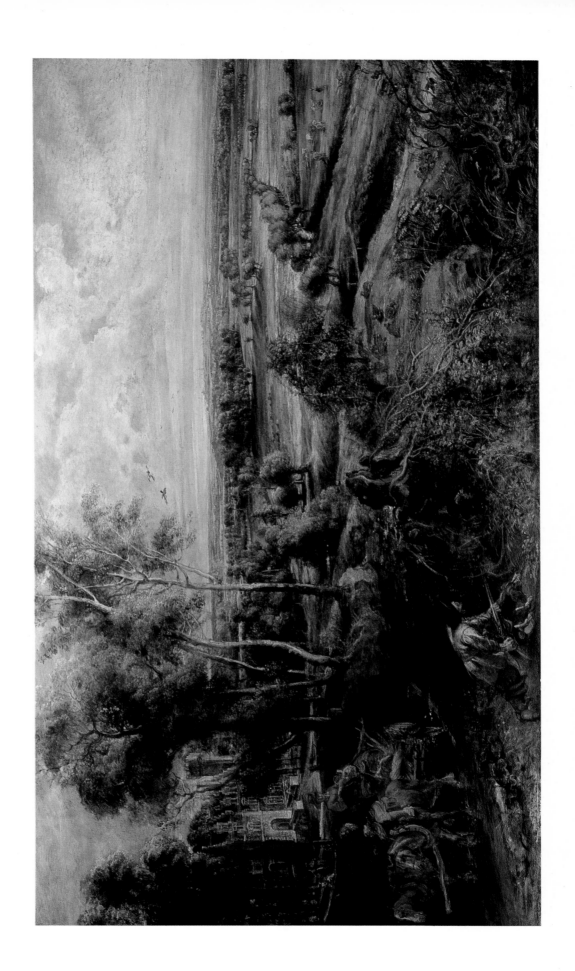

PLATE 19

Peter Paul Rubens (1577–1640)

The Rape of the Sabine Women

Wood (oak), 169.9 × 236.2 cm.
Purchased with the Angerstein collection, 1824

The story depicted here by Rubens is told by Plutarch in his *Lives*. After the discovery of an altar in Rome, Romulus declared that games were to be held to which the Sabines, a tribe who lived to the north-east of Rome, were to be invited. When Romulus, who is shown seated in the top right-hand corner of the painting, gave a prearranged signal, the Romans carried off a number of Sabine women. Later the Sabines, led by Tatius, attacked the Romans but were defeated.

Rubens shows the moment when the Romans began to abduct the Sabine women. The artist was extremely interested in and knowledgeable about the ancient world and he correctly shows Romulus and the women set back from the games behind a rail. The arch is festooned in the appropriate classical manner with garlands of flowers: in the background the Romans and the Sabines fight. Despite the authentic classical details, however, the Sabine women are deliberately shown in contemporary Flemish dress. Although the violence of the event is real enough, the painting is not horrifying or tragic. While individual faces are masks of hysteria and panic, the whole is scarcely credible as tragedy to an eye accustomed to naturalistic painting. We may come closer to the true spirit of the picture if we view it as an exciting, dynamic composition rendered with the delicate beauty of muted tones: the fragile colours of the silks and satins of the women's dresses are contrasted with the sombre uniforms of the Romans. The painting constantly delights the eye, which is led beyond the composition by outstretched arms and legs, with unexpected subtleties of colour and texture.

The picture dates from about 1635–7. It was part of the Angerstein collection that formed the basis of the National Gallery when it was founded in 1824.

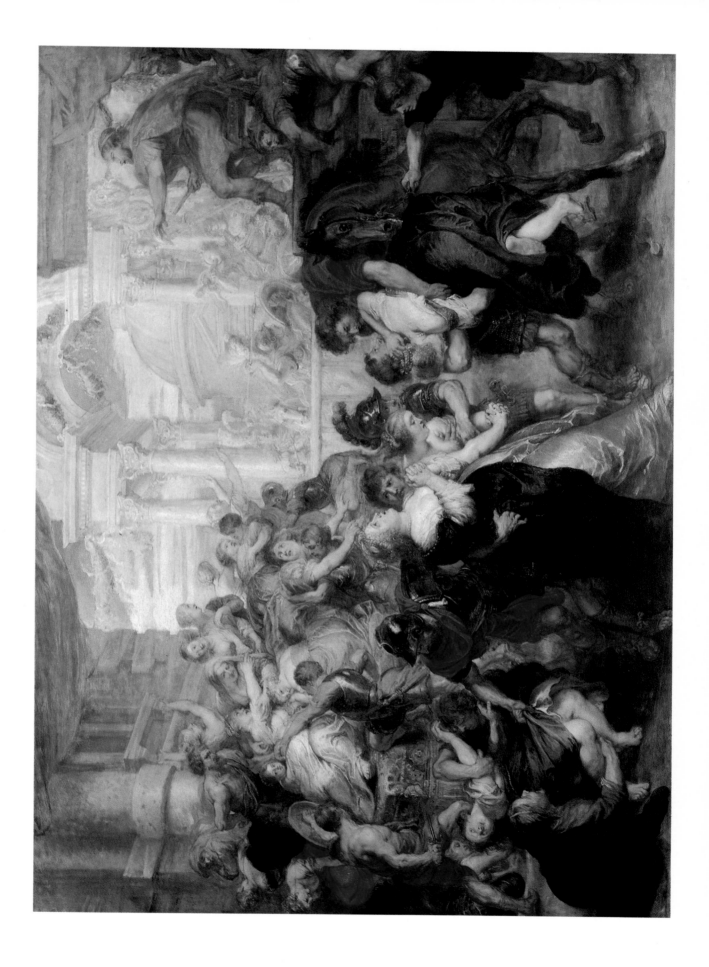

PLATE 20

Peter Paul Rubens (1577–1640)

Aurora abducting Cephalus

Wood (oak), approximately 30.8 × 48 cm.
Salting Bequest, 1910

In the autumn of 1636 Rubens received an important commission from King Philip IV of Spain. Philip had constructed a hunting lodge, the Torre de la Parada, almost nine miles outside Madrid, and he wanted to decorate it with hunting scenes and mythological subjects. This was a huge project – about 120 subjects were required – and paintings were also commissioned from Velázquez. Rubens was to design almost all the paintings, but the majority of the pictures were to be executed from his sketches by other Flemish artists. These pictures were signed by, or inscribed with, the individual artists' names.

This is one of the sketches for the Torre de la Parada. Although it dates from the last few years of Rubens' life, when he was often troubled by ill-health, it shows not only the undimmed power of his imagination but a remarkable freshness and spontaneity of handling. The sketch is basically in light brown but enlivened by the reds and yellows of the draperies. The larger painting, for the Torre de la Parada itself, does not survive. Most of the finished paintings, however, are in the Prado Museum in Madrid, as are many of the sketches.

The story of Aurora and Cephalus is told by Ovid in *Metamorphoses*, the source for most of the mythological scenes in the Torre de la Parada. But in Ovid's account Cephalus, the mortal huntsman, does not return the passion felt towards him by the goddess Aurora. According to Ovid, Cephalus was faithful to his wife, Procris. In Rubens' painting Cephalus, who is resting after the hunt, his sleeping dogs and javelin at his side, welcomes the goddess with his extended right arm. Here Rubens seems to have followed the versions of the myth told by Hesiod and Pausanias.

The painting is recorded in the collection of the Duque de Infantado in Madrid in 1776. It passed by inheritance into the Osuna family and was seen in the collection of the 12th Duque de Osuna by Sir Charles Eastlake in 1859. It was bought at a sale of Osuna paintings in Madrid in 1896 by George Salting. He bequeathed it to the National Gallery in 1910.

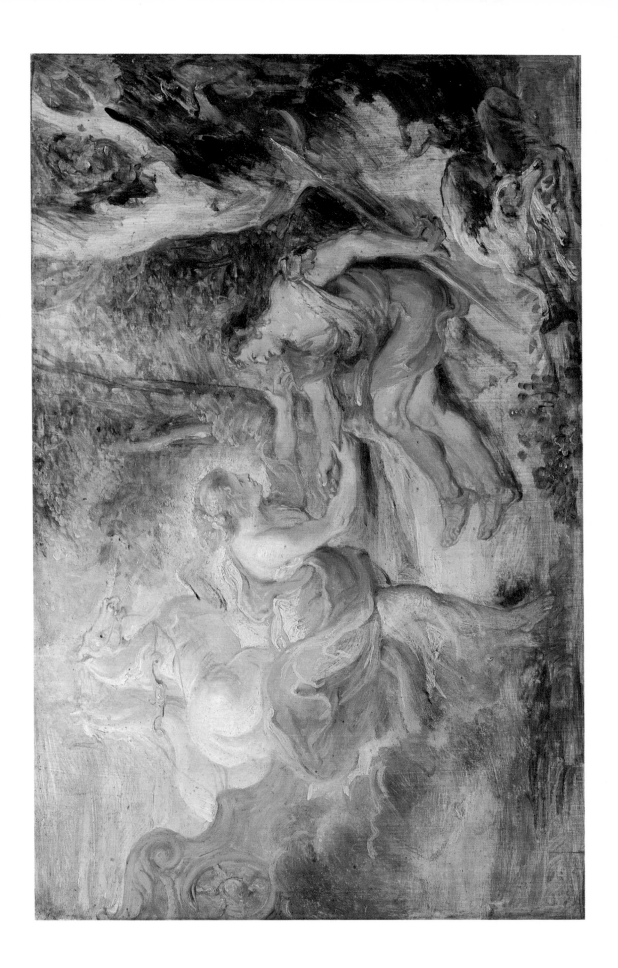

PLATE 22

Hendrick van Steenwyck the Younger (active by 1604, died 1649)

A Man kneels before a Woman in the Courtyard of a Renaissance Palace

Signed and dated: H. V. STEINWY(?)CK·1610·
Copper, 40.2 × 69.8 cm.
Bequeathed by Lt.-Col. J. H. Ollney, 1837

Hendrick van Steenwyck the Younger, like his father of the same name, specialised in architectural scenes. Many are of church interiors, some of actual buildings, but he also painted architectural fantasies such as this one. The palace is the setting for an unidentified classical scene, perhaps Aeneas in the palace of Dido, but the real subject of the painting is the architecture itself. It is constructed like a perspective exercise, modelled on the engravings from Vredeman de Vries' influential *Perspectiva*, published in Antwerp in 1602. The ambitious design, with its arcaded Italianate *palazzi*, topped by statues and obelisks, its tall towers and flamboyant Flemish stepped gables, gives the artist an opportunity to display his technical abilities. The lines of perspective, or orthogonals, thinly disguised as steps and balustrades, all lead – as de Vries required they should – to a single vanishing point. The buildings are intended to be imaginary and yet suggestive of recognisable models.

Recent cleaning has much improved the highly-wrought surface of the painting, in particular reclaiming the elaborate marbling of the columns in the foreground. The thinly painted figures have obviously been applied by another hand on top of the architectural detail. Steenwyck often collaborated with figure painters but in this case the other artist has not been identified.

PLATE 21

Peter Paul Rubens (1577–1640)

A Landscape with a Shepherd and his Flock

Wood (oak), approximately 49.4 × 83.5 cm.
Bequeathed by Lord Farnborough, 1839

For Rubens landscape painting seems to have been a private occupation. Many of his landscapes were still in his possession at the time of his death. This, painted only about two years before the artist's death, is the latest of the National Gallery's outstanding group of Rubens' landscapes. It is a gentle, reflective painting probably inspired by the countryside about his house at Het Steen. The sinking sun, painted with broad strokes of a heavily-loaded brush, causes the water to sparkle and the sheeps' fleeces to glow. Its tranquillity and mellow contentment mirror Rubens' own mood in his last years, living with his growing family in the country at Het Steen.

After Rubens' death this painting was probably among those sold by his family in Antwerp in 1640. It may have been in the notable collection of the banker Everhard Jabach in Paris. It was certainly in that of his granddaughter in 1724. It was in a sale in Paris in 1804 and had been purchased by the Hon. Charles Long, later Lord Farnborough, by 1810. Long was a close friend and the artistic adviser of the Regent, who ascended the throne as George IV. It was bequeathed to the National Gallery by Lord Farnborough in 1839.

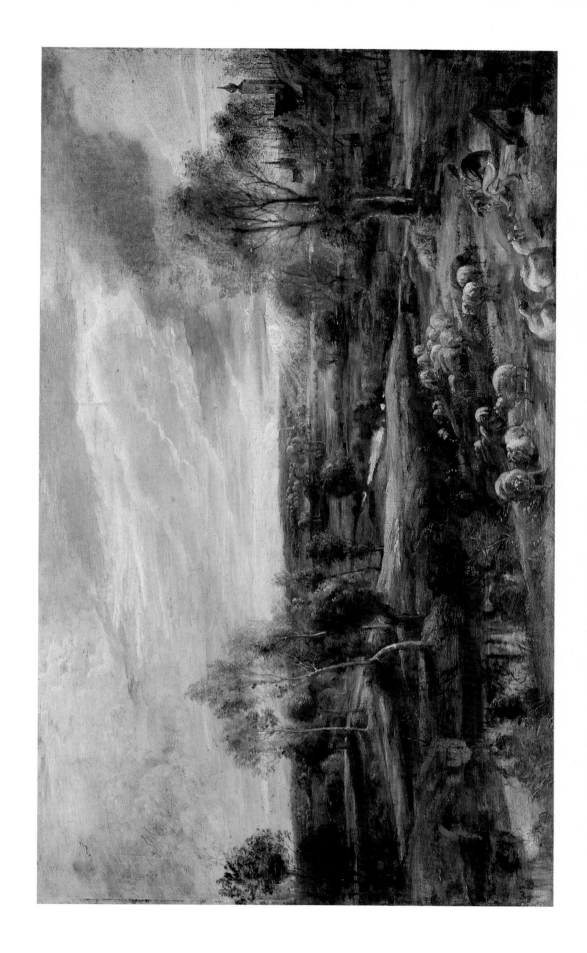

PLATE 22

Hendrick van Steenwyck the Younger (active by 1604, died 1649)

A Man kneels before a Woman in the Courtyard of a Renaissance Palace

Signed and dated: H. V. STEINWY(?)CK·1610·
Copper, 40.2 × 69.8 cm.
Bequeathed by Lt.-Col. J. H. Ollney, 1837

Hendrick van Steenwyck the Younger, like his father of the same name, specialised in architectural scenes. Many are of church interiors, some of actual buildings, but he also painted architectural fantasies such as this one. The palace is the setting for an unidentified classical scene, perhaps Aeneas in the palace of Dido, but the real subject of the painting is the architecture itself. It is constructed like a perspective exercise, modelled on the engravings from Vredeman de Vries' influential *Perspectiva*, published in Antwerp in 1602. The ambitious design, with its arcaded Italianate *palazzi*, topped by statues and obelisks, its tall towers and flamboyant Flemish stepped gables, gives the artist an opportunity to display his technical abilities. The lines of perspective, or orthogonals, thinly disguised as steps and balustrades, all lead – as de Vries required they should – to a single vanishing point. The buildings are intended to be imaginary and yet suggestive of recognisable models.

Recent cleaning has much improved the highly-wrought surface of the painting, in particular reclaiming the elaborate marbling of the columns in the foreground. The thinly painted figures have obviously been applied by another hand on top of the architectural detail. Steenwyck often collaborated with figure painters but in this case the other artist has not been identified.

PLATE 9

Peter Paul Rubens (1577–1640)

A Shepherd with his Flock in a Woody Landscape

Wood (oak), approximately 63.9 × 94.3 cm.

Presented by Rosalind, Countess of Carlisle, 1913

It is very difficult to place Rubens' landscapes within the general chronology of his work. Many of his landscapes, like the *Autumn Landscape with a View of Het Steen* (Plate 18), date from the last decade of his life when he came to spend more and more time with his young family at his country house. This picture, however, and the other landscape in the National Gallery to which it is closely related, the so-called *"Watering Place"* (Plate 8), are usually believed to have been painted earlier in his career, probably between 1615 and 1622. Rubens used the composition of this painting as the basis of that in the far more complex *"Watering Place"*.

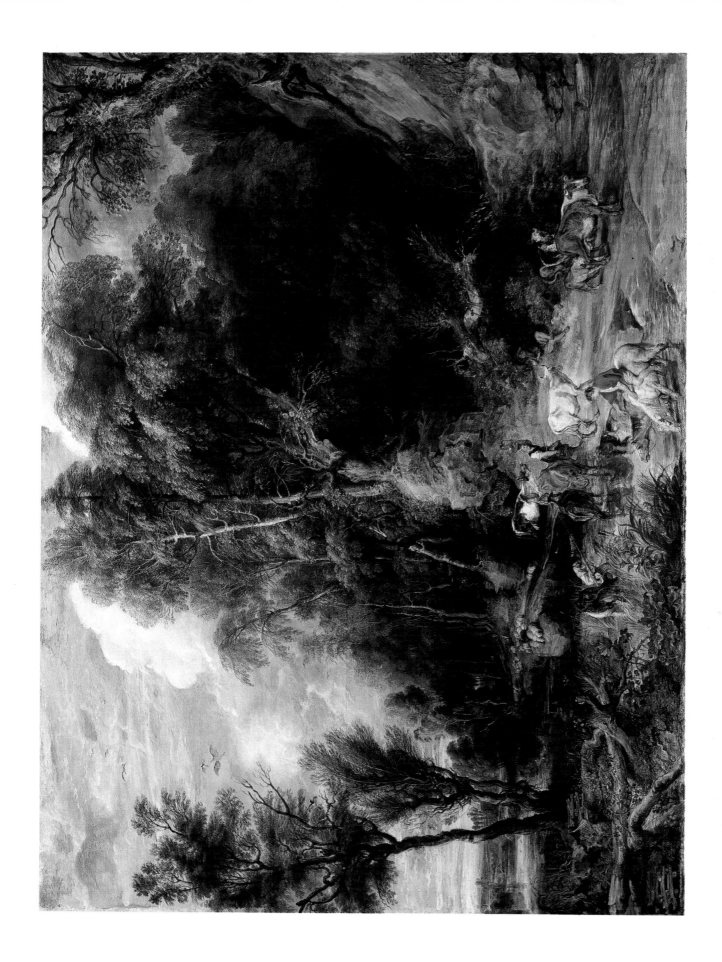

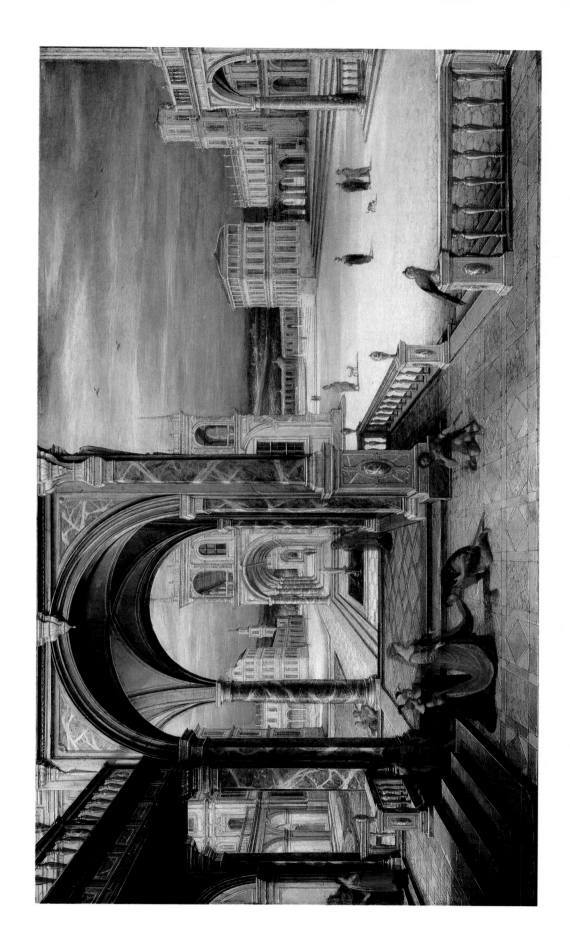

PLATE 23

Pieter Neeffs the Elder (active 1605, died between 1656 and 1661) and Bonaventura Peeters the Elder (1614–1652)

An Evening Service in a Church

Signed and dated: PEETER. NEEFS./1649
Wood (oak), 26.8 × 38.2 cm.
Bequeathed by Henry Calcott Brunning, 1907

Pieter Neeffs the Elder was one of a number of artists working in Antwerp during the seventeenth century who specialised in painting church interiors. Hendrick van Steenwyck and his son, also Hendrick, painted church interiors as did Pieter Neeff's own son. He too was called Pieter and their work is hard to differentiate. Both these families of painters based their markedly linear styles on the architectural engravings of Hans Vredeman de Vries, an Antwerp artist whose influential treatise on perspective was published in 1602. Hendrick van Steenwyck the Elder had been a pupil of de Vries and his paintings are often little more than coloured versions of his master's engravings. Pieter Neeffs was probably in his turn a pupil of Steenwyck, whose style he refined and developed while retaining its basic linearity.

The painter's skill in rendering perspective recession is still the single most important feature of his work but, as here, he is also concerned with the play of shadows softening the outlines of the architectural elements and mottling the surfaces of the walls. The figures in the painting are by another artist, almost certainly Bonaventura Peeters the Elder, who is best known for his marine paintings but who also frequently collaborated with Neeffs. The church has not been identified and may well be imaginary, though based on the great gothic churches of Antwerp and, in particular, on the cathedral.

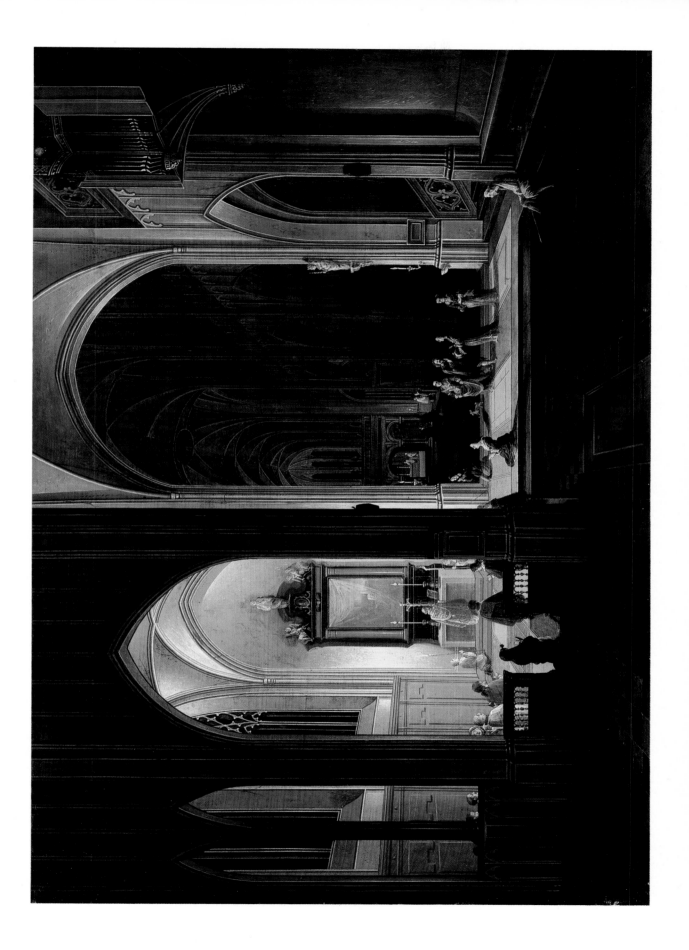

PLATE 24

Flemish School (around 1620)

Cognoscenti in a Room hung with Pictures

Wood (oak), approximately 95.9 × 123.5 cm.
Bequeathed by John Staniforth Beckett, 1889

This room, crammed with paintings, sculpture and other *objets d'art*, is imaginary: it is an ideal gallery. If ever such a group of works were owned by an Antwerp collector they would have been displayed throughout a large house rather than massed together in this way. It is more likely, however, that the collection itself is imaginary too, that it represents the best of what was available in private collections in Antwerp in 1620. The figures may well be portraits: they are unidentified but these men are presumably notable local collectors and scholars.

The paintings provide a fascinating view of the Antwerp school in the late sixteenth and early seventeenth centuries. The styles of almost all of them can be identified, and among them are paintings by many of the artists represented in this book. There is, on the far left, a church interior by Hendrick van Steenwyck the Younger and a *Landscape with Windmill* and a *Still Life* by Jan Brueghel the Elder. On the back wall there are further paintings by these two artists, as well as others by Joachim Beuckelaer, Joos de Momper, Johann Rottenhammer, Jan Wildens, Paul Bril, Frans Francken, Hendrick van Balen and others. In the group on the right-hand wall are paintings by Rubens. The paintings propped up in the foreground are by Jan Brueghel, David Teniers the Elder and Frans Snyders.

On the table at the left are, among other objects, a celestial globe, an astrolabe and a compass, which point to the scholarly, scientific interests of their owners. Also on the table is a loose print of *Ceres mocked by Peasants* engraved by Goudt after Elsheimer and, in the open folio, prints by Dürer and Lucas van Leyden. All these items, as well as the statuettes, coins, miniatures and drawings, were collected by connoisseurs in early seventeenth-century Antwerp. But there is one disquieting element: on the windowsill on the left is a monkey, a traditional symbol of the foolishness of man's endeavours. Unobserved, he mocks this accumulation of riches and beauty as well as the vain striving after knowledge.

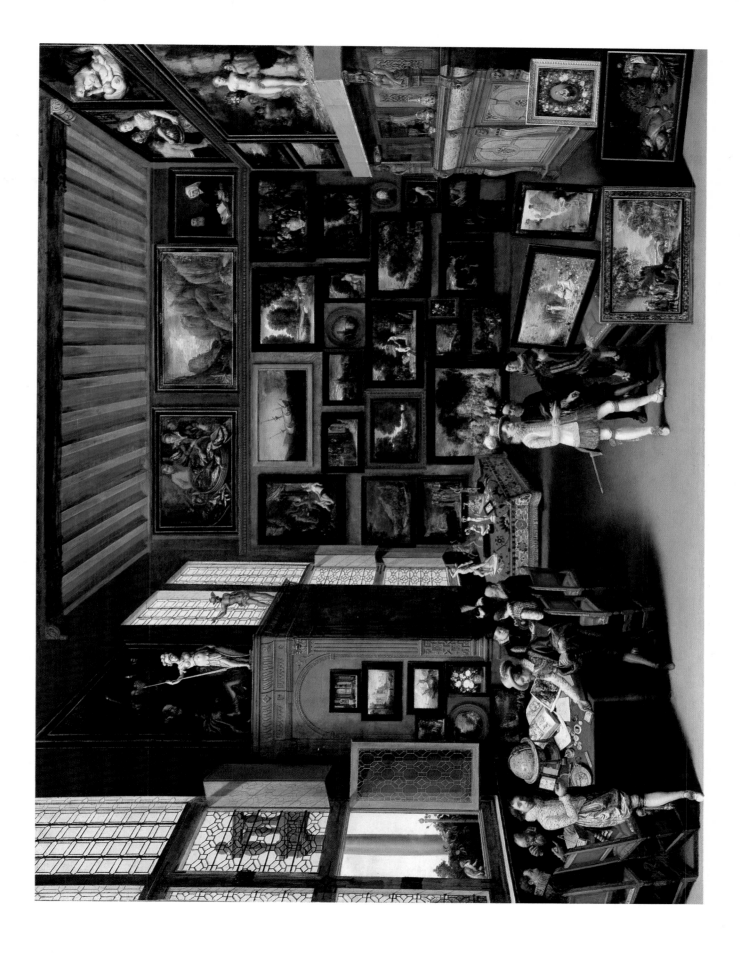

PLATE 25

Jacob Jordaens (1593–1678)

The Virgin and Child with Saints Zacharias, Elizabeth and John the Baptist

Canvas, approximately 114 × 151.8 cm.
Purchased, 1917

After the death of Rubens in 1640 Jacob Jordaens was said by Balthasar Gerbier to be the "prime painter" in Antwerp. He was then forty-seven and had been a master in the guild of Saint Luke since 1615. He had been a pupil of the Antwerp figure-painter Adam van Noort, whose daughter he married in 1616. Jordaens had been elevated, as it were, to the ruling triumvirate of Flemish painting in 1628 when he, van Dyck (who was four years his junior) and Rubens were each commissioned to paint an altarpiece in the Augustinian church in Antwerp. In 1636 Jordaens was one of the artists who executed paintings after designs by Rubens for the Torre de la Parada, Philip IV of Spain's hunting-lodge in Madrid (see Plate 20). Subsequently Jordaens received commissions from Charles I of England, the Queen of Sweden, the Prince of Orange and the burgomasters of Amsterdam.

The subject of this painting – the visit of the Virgin and Child to Saint John the Baptist and his parents, Elizabeth and Zacharias – is not recorded in the Bible. It is to be found instead in one of the earliest commentaries on the Bible, the *Meditations* of the so-called Pseudo-Bonaventura. A number of deliberate symbols can be detected in the painting: the bird in a cage was a long-established symbol of the imprisonment of the soul in the mortal body, from which it could be liberated by the coming of Christ; the goldfinch represents the Passion, and Christ's pointing towards the bird suggests His longing for it; the lamb is the emblem of Saint John, who had foretold the Passion.

The picture was probably painted by Jordaens in about 1620. There is another version of it, likely to have been painted first, in the North Carolina Museum of Art in Raleigh. Such repetitions by the artist, a consequence of the demand among contemporary collectors for Jordaens' work, were quite usual in seventeenth-century Flanders.

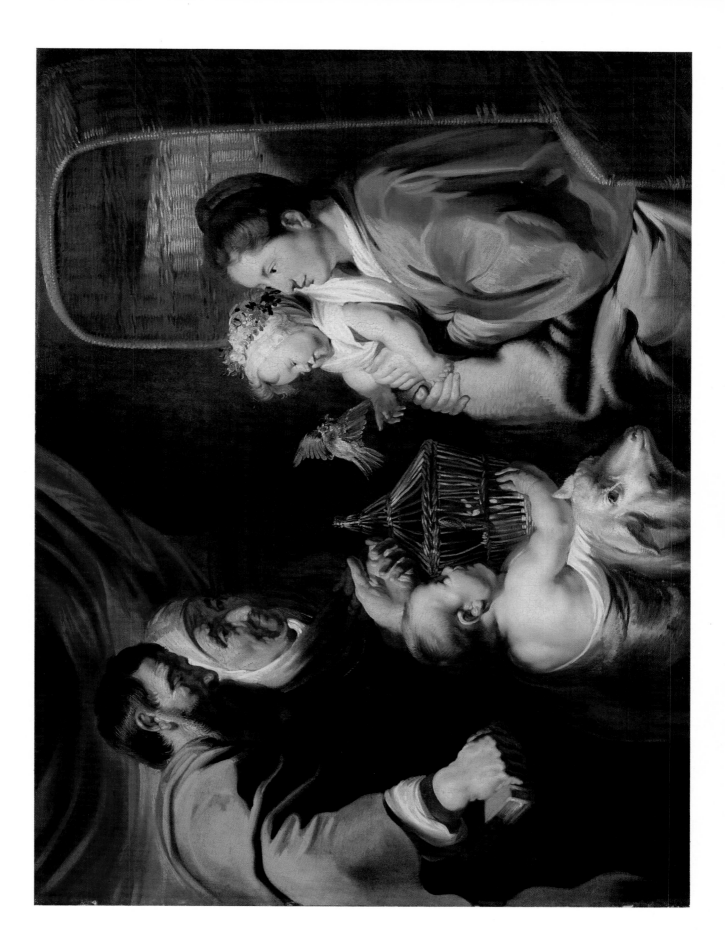

PLATE 26

Jacob Jordaens (1593–1678)

The Holy Family and Saint John the Baptist

Wood (oak), 123 × 93.9 cm.
Presented by the Duke of Northumberland, 1838

Although Jordaens himself was a Protestant – he was able to declare his beliefs in public only after the Peace of Munster in 1648 – the iconography of this and many other of his religious paintings is impeccably Catholic. The prominence of the rosary associates it with the Catholic cult of the rosary, which flourished strongly in Flanders in the early seventeenth century. Caravaggio's *Madonna of the Rosary* (now in Vienna) was acquired for the Dominican church in Antwerp probably in the early 1620s, and Jordaens' painting, which in its strong, dramatic contrasts of light and shadow may well reflect his study of Caravaggio's work, is likely to have been painted at about that time. It is a particularly moving image because of the remarkably naturalistic treatment of the young, beautiful and timid Virgin and the vigorous, black-bearded Joseph who is so different from the usual elderly white-haired patriarch.

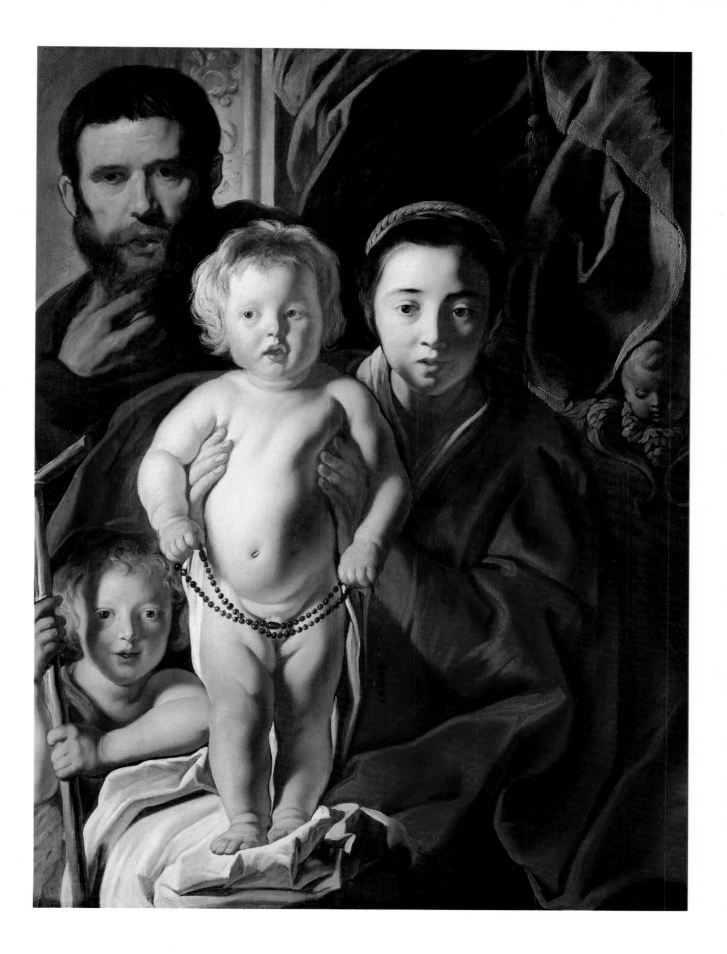

PLATE 27

Jacob Jordaens (1593–1678)

Portrait of Govaert van Surpele (?) and his Wife

Canvas, 213.3 × 189 cm.

Acquired from the Duke of Devonshire by application of the 1956 Finance Act, 1958

Jordaens was primarily a painter of religious, mythological and genre scenes. He rarely painted portraits, but when he did his style was ideally suited to the representation of his solid, secure and soberly dressed Flemish contemporaries. Van Dyck and Jordaens adopted different aspects of Rubens' manner: Jordaens chose to emphasise the weight of his figures, using his creamy flesh-tones and the deeper, darker end of his palette. Van Dyck transformed the merchants of Antwerp into elegant courtiers, but Jordaens' heavier, more three-dimensional style was doubtless nearer the truth.

The coat of arms in the centre is that of the van Surpele family from the town of Diest which is in south Brabant not far from Brussels. The most likely member of the family to be shown here is Govaert van Surpele (1593–1674) who held important posts in the civic administration. He served as burgomaster on three occasions. He married twice: in 1614 he married Catharina Cools, who died in 1629, and in 1636 he married Catharina Coninckx who died in 1639. This painting is likely to date from shortly after van Surpele's second marriage in 1636. It is not, however, a marriage portrait but rather it commemorates van Surpele's appointment to a public position. This is indicated by his symbol of office – the staff – which is so prominent in the painting and to which his wife points. The post was probably that of *président de la loi* which van Surpele held in the year 1636/7.

The portrait was in the collection of the Duke of Devonshire at Devonshire House in London by 1743 and remained in the family until it was ceded to the National Gallery in 1958.

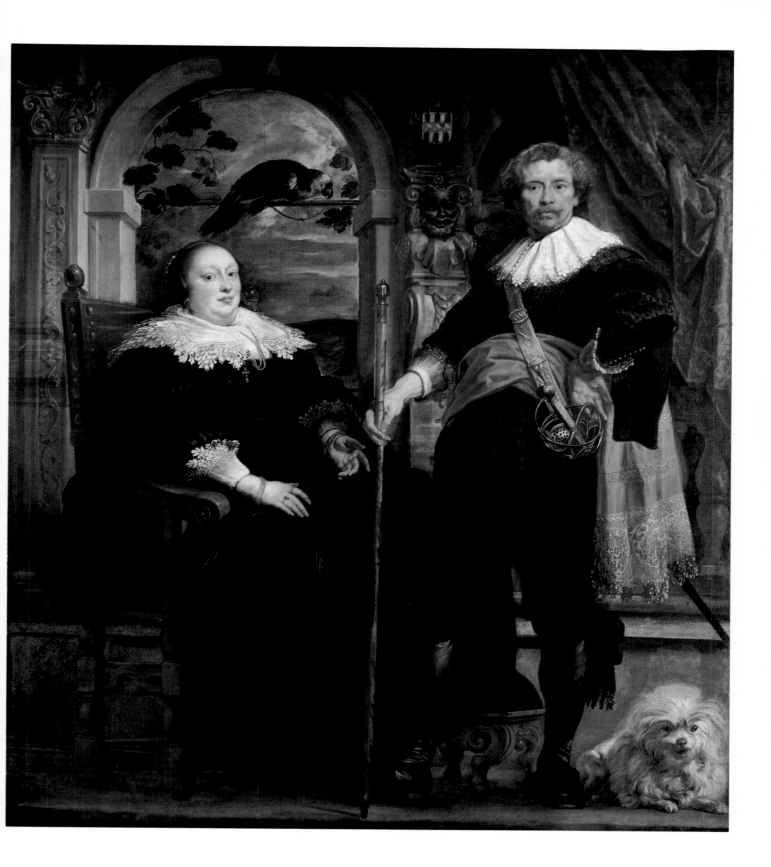

PLATE 28

Lucas van Uden (1595–1672) and David Teniers the Younger (1610–1690)

Peasants merry-making before a Country House

Signed: D TENIERS
Canvas, approximately 178.5 × 264.2 cm.
Presented by John Hanbury Martin, 1948

Lucas van Uden, who lived and worked in Antwerp, was a specialist in landscape. He had been trained by his father and entered the painters' guild as a master in the year of his father's death in 1627 or 1628. His work shows close affinities to Rubens' landscape style although it is not known whether or not van Uden actually worked in his studio. He collaborated with Rubens, David Teniers and other figure painters.

It is interesting to compare this view with Teniers' own *View of Het Sterckshof near Antwerp* (Plate 44) since both paintings use an actual house for the backdrop of a figure scene. In the Teniers picture the figures may be portraits, but here they are simply peasant types. Their function is largely decorative, enlivening the foreground of what is effectively a portrait of a house with its elegant colonnade of trees and its formal garden seen in steep perspective. Unfortunately the house, with its two towers on the front, stepped gables at the side, imposing doorway and moat, has not been identified. Van Uden has not resolved a basic problem of landscape, a problem that also defeated Rubens in his *Autumn Landscape with a View of Het Steen* (Plate 18): the transition from foreground to background. He uses the device of a rocky outcrop to disguise this transition, but with little success. More effective is the background itself, the fields dotted with clumps of stubby trees and dominated by the profiles of churches and a windmill. The picture probably dates from about 1650.

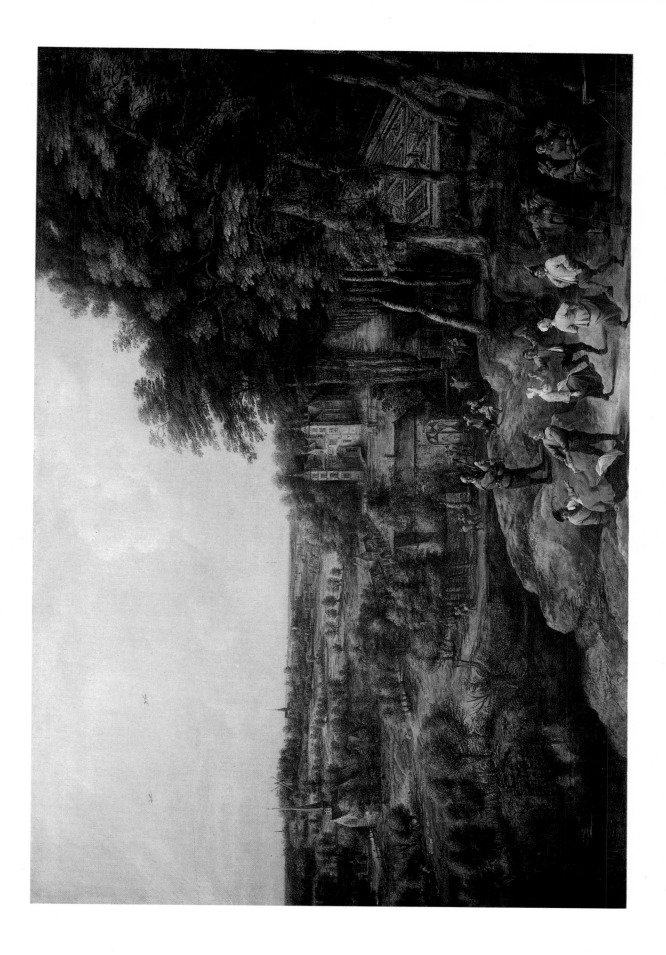

PLATE 29

Justus Sustermans (1597–1681)

Double Portrait of the Grand Duke Ferdinand II of Tuscany and his Wife Vittoria della Rovere

Canvas, approximately 161 × 147 cm.
Purchased with the Angerstein collection, 1824

It was usual for talented young Flemish painters to complete their apprenticeship with a visit to Italy in order to study the works of antiquity as well as Renaissance and contemporary painting. What was far less usual was to settle there as Sustermans did. He was born and trained in Antwerp; he left the city in about 1616 for Paris, where he worked in the studio of Frans Pourbus the Younger, another Flemish painter who had lived and worked in Italy and had travelled to France in the entourage of Maria de' Medici. It was no doubt at Pourbus' suggestion that Sustermans travelled to Florence in 1619 or 1620 and there entered the service of the Grand Duke Cosimo II. Cosimo died in 1621 but Sustermans was to remain as court painter to the Grand Duke of Tuscany until his death. He was an immensely successful portrait painter, working not only for the rulers of Tuscany but for the Emperor Ferdinand II at Vienna, Archduke Ferdinand of Austria at Innsbruck and many of the smaller Italian courts.

The sitter of this portrait is Cosimo II's son, Ferdinand II de' Medici (1610–1670). A child at his father's death, he assumed power in 1627. He is wearing the cross of the military order of San Stefano, founded by his grandfather, Cosimo de' Medici, in 1561. He married Vittoria della Rovere in 1634. This double portrait was probably painted in the first half of the 1660s.

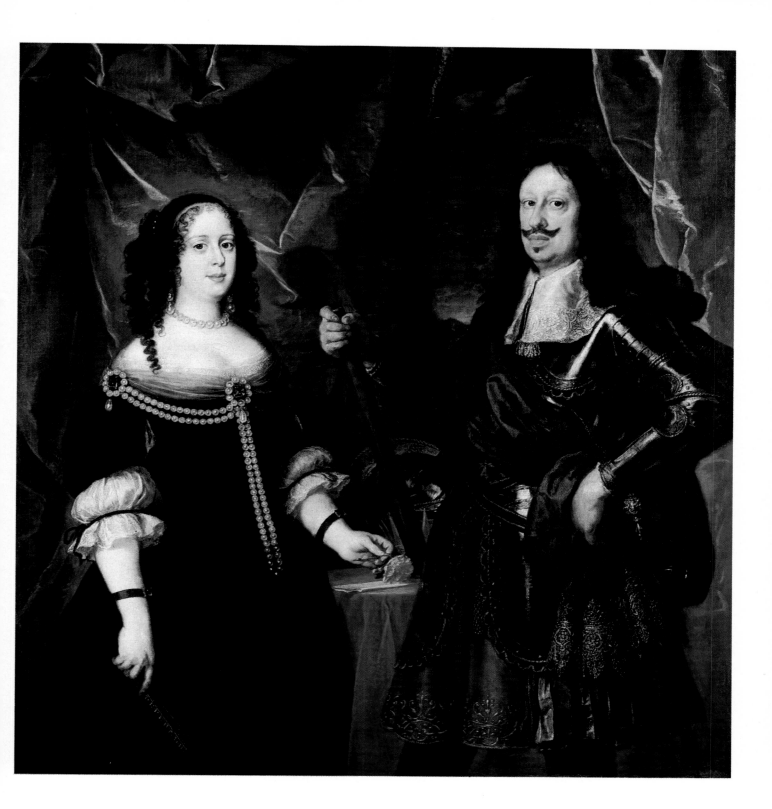

PLATE 30

Anthony van Dyck (1599–1641)

The Emperor Theodosius is forbidden by Saint Ambrosius to enter Milan Cathedral

Canvas, 149 × 113.5 cm.
Purchased with the Angerstein collection, 1824

Saint Ambrosius, Archbishop of Milan from 374, refused the Emperor Theodosius permission to enter his cathedral because of Theodosius' savage treatment of the inhabitants of Thessalonica who had murdered his general, Butheric. In one account Ruffinus, master of the emperor's knights, attempted to intercede and was rebuked by Ambrosius for having 'no more shame than a hound'. Ruffinus is presumably the figure in armour on the left, in front of whom a dog stands on the steps.

The picture was painted in about 1619, when van Dyck was only twenty. He was a prodigy who had had his own independent studio at sixteen. In the years around 1620, however, van Dyck was working closely with Rubens and was his principal assistant on the project for the decoration of the new Jesuit church in Antwerp. *The Emperor Theodosius* is a free copy of a much larger painting by Rubens now in the Kunsthistorisches Museum in Vienna. A comparison of the two points up the younger painter's strengths and weaknesses. In Rubens' painting the figures have weight and substance. Saint Ambrosius, we feel, is capable of physically preventing Theodosius from entering the cathedral. In van Dyck's treatment, by contrast, the encounter has lost that physical sense and the refusal has become an elegant ritual, at the centre of which is the delicate pattern made by the tapering fingers of the emperor and archbishop's hands. In Rubens' painting, Ambrosius' cape is both weighty and elaborately patterned: in van Dyck's, its thread of gold shimmers and appears to float on the very surface of the canvas. The head of the man standing second from the right is strongly characterised and is probably intended to be a portrait of Nicolaas Rockox, the Antwerp burgomaster and influential patron of the arts for whom Rubens painted the *Samson and Delilah* (Plate 3).

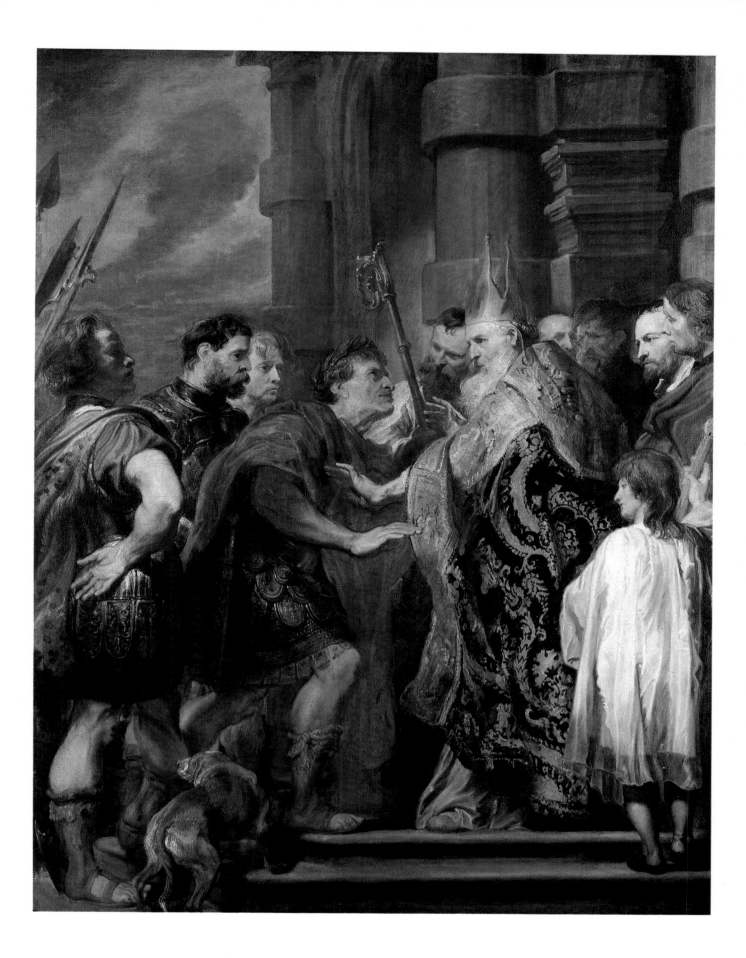

PLATE 31

Anthony van Dyck (1599–1641)

Portrait of Cornelis van der Geest

Wood (oak), approximately 37.5 × 32.5 cm.
Purchased with the Angerstein collection, 1824

Cornelis van der Geest (1555–1638) was a prosperous spice merchant in Antwerp, an influential member of the city's business community, a collector and an important patron of the arts. He had played a key role in Rubens' early career, securing for him in 1610, shortly after his return from Italy, the commission for the *Elevation of the Cross* for the high altar of the church of St Walburga, van der Geest's parish church. It was this altarpiece that established Rubens' reputation as the leading painter of religious subjects in Antwerp. When Rubens' composition was eventually engraved in 1638 he dedicated it posthumously to "Cornelis van der Geest, the best of men and my oldest friend, who, since my youth, has been my never-failing patron, whose whole life showed a love and admiration of painting". The extent of van der Geest's impressive collection of sixteenth- and seventeenth-century Flemish painting can be seen in a picture by Willem van Haecht which today hangs in the Rubenshius in Antwerp. It records a visit made by the Archduke Albert and Archduchess Isabella to van der Geest's house in 1615. The walls of the principal room are literally crammed with paintings by Quentin Massys as well as by contemporary Antwerp artists including Rubens, Snijders and Jan Brueghel the Elder.

Van Dyck's portrait of van der Geest was painted in about 1620 when the sitter was sixty-five and the precocious artist only twenty-one. It is undoubtedly the masterpiece of van Dyck's early portrait style. He has used a traditional format, a close-up of the face framed by the ruff, which he has animated by the skilful use of delicate brush strokes and highlights. The touches of white on the corners of the eyes brilliantly suggest moistness, but it is the alertness of the features that particularly distinguishes this remarkable portrait.

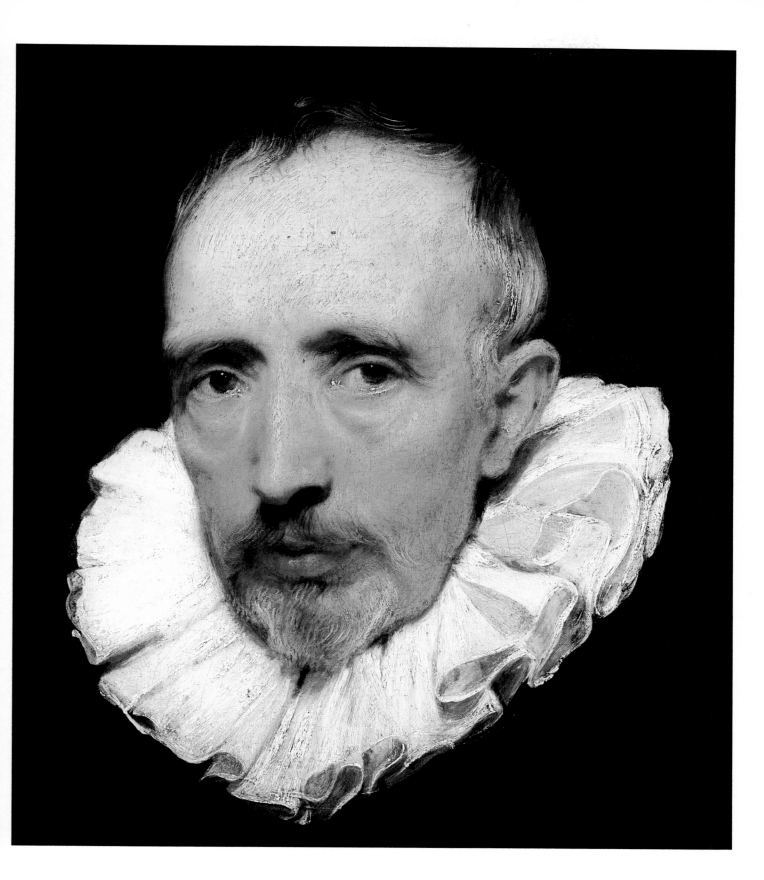

PLATE 32

Anthony van Dyck (1599–1641)

Portrait of a Woman and Child

Canvas, 131.5 × 106.2 cm.
Purchased, 1914

Painted at about the same time as the masterly portrait of Cornelis van der Geest (Plate 31) in around 1620, this is another example of the young van Dyck's precocious skill as a portrait painter. His style is economical – the richness of silk and the stiffness of starched lace are conjured up with a very few instinctively placed brush strokes. Yet, as in the *Cornelis van der Geest*, what lifts van Dyck's portraiture far above the level of almost all his contemporaries is not just his remarkable skill in rendering differing textures but the animation and vivacity of his sitters. Here the woman smiles modestly at the spectator while the child's attention has been caught momentarily by something outside the picture.

The mother and child have not been identified, though they are certainly intended to be portraits. It seems likely that the painting originally had a pendant showing the husband and perhaps a second child. The painting is first recorded in the Palazzo Balbi in Genoa in 1758 but it is not clear whether it dates from van Dyck's stay in the city or whether it was painted shortly before his departure from Antwerp for Italy.

PLATE 33

Anthony van Dyck (1599–1641)

Portrait of George Gage (?) with Two Attendants

Canvas, 115 × 113.5 cm.
Purchased with the Angerstein collection, 1824

The coat of arms on the pedestal and the carved ram's head identify the sitter as a member of the Gage family, presumably George Gage (around 1592–1638), who would have been about thirty when this portrait was painted. George was a diplomat, "a graceful person, of good address, well skill'd in musick, painting and architecture; a master of several languages", according to a contemporary. He was one of Charles I's most effective agents in the creation of his great collection of works of art and also bought pictures and sculpture on behalf of the Duke of Buckingham and Sir Anthony Carlton. He may well have met van Dyck during a visit to Antwerp in 1620. It is difficult to be sure when van Dyck painted Gage: it could have been during the winter of 1620/21 when van Dyck was in London, or in 1622 or 1623 when both men were in Rome. Van Dyck shows Gage inspecting an antique statuette which he has no doubt been offered for sale. The broad style – the sky, landscape and architecture are mostly sketched in – suits the subject. It enables van Dyck to convey the sense of a moment being frozen. In the face of the earnest entreaties of the vendors, Gage registers interest but, like a skilful poker player, is careful not to appear too enthusiastic. There is, we may be sure, some serious haggling to come.

The painting was owned by Sir Joshua Reynolds, at one of the sales of whose collection in 1795 it was purchased by Angerstein for £147.

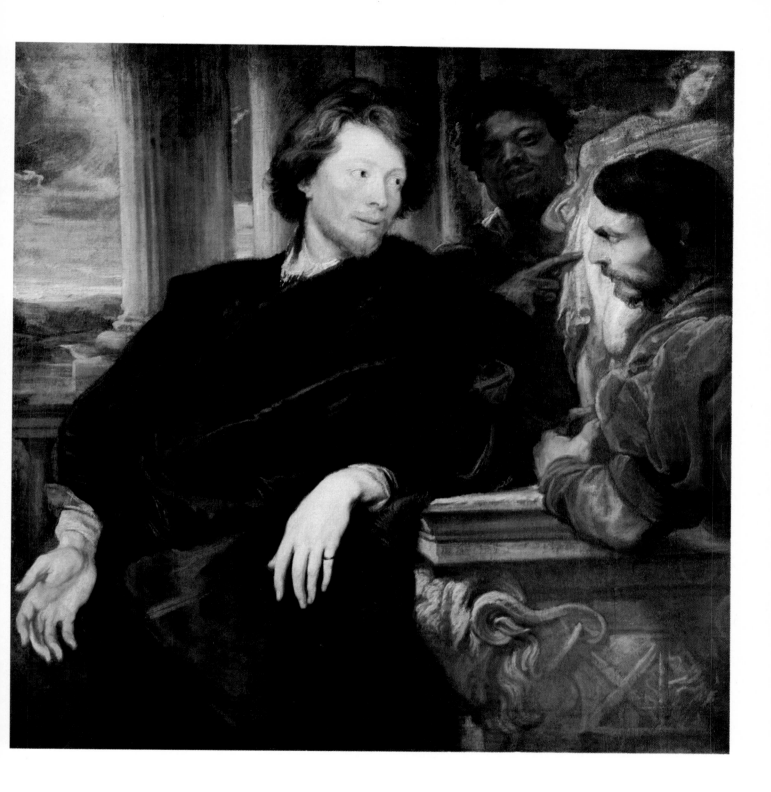

PLATE 34

Anthony van Dyck (1599–1641)

"*The Balbi Children*"

Canvas, 219 × 151 cm.
Purchased with the aid of a contribution from the J. Paul Getty Jnr. Endowment Fund, 1985

This portrait group, which shows three young sons of an aristocratic Genoese family, was painted by van Dyck between 1625 and 1627 when he was living in that city. It has been known traditionally as "*The Balbi Children*" but in fact there is no firm evidence for their identification as members of one of the many branches of the Balbi family.

Van Dyck travelled to Italy late in 1621 when he was twenty-two years old. His first stop was Genoa, where he stayed with his friends from Antwerp, the brothers Cornelis and Lucas de Wael, who were painters and art dealers. Throughout his six years in Italy van Dyck travelled extensively in the peninsula and was in Sicily for several months. Much of his travelling was done during his first three years and he seems to have spent most of 1625–7 in Genoa, where he enjoyed great success as a portraitist to the local nobility. The elegance and richness of his portrait style were ideally suited to these aristocrats: he placed them against imposing architectural backgrounds and cascading, richly coloured curtains, elongating their figures to imbue them with a sense of authority and remoteness.

In "*The Balbi Children*" van Dyck has placed the boys on steps between two monumental columns and beneath a looped-up curtain. What is parti-cularly effective, however, is the portrayal of each of the three boys, the vivacity of their expressions, their intimate compositional relationship and the virtuosity of the painting of their heads and their rich, embroidered clothes. Their pet choughs in the foreground add a further, lively element to the composition. It is in the tension between the formality of the setting and the individuality of the boys that much of the painting's success resides.

The picture is mentioned for the first time in the 1740 inventory of the collection of Giacomo Balbi, but it seems likely that his father had purchased it early in the eighteenth century from another aristo-cratic family in Genoa or from another of the many branches of his own family. It was purchased from a descendant of Giacomo Balbi, the Marchesa Violante Spinola, on behalf of William, 2nd Baron Berwick, in 1824 or 1825 and hung at the Berwick family house, Attingham, until 1842 when it was sold to Thomas Philip, 2nd Earl de Grey. Sub-sequently the painting passed by marriage into the great Cowper collection at Panshanger. It came on loan to the National Gallery in 1909 and was here, with short breaks, until 1962. It was purchased in 1985 by private treaty sale from a descendant of Earl de Grey.

PLATE 35

Anthony van Dyck (1599–1641)

Charity

Wood (oak), 148.2 × 107.5 cm.
Purchased, 1984

Charity (*Caritas*) is one of the theological virtues and van Dyck brings to his depiction of her the same religious intensity that characterises his paintings of the Virgin and Child and scenes from the Passion. Although van Dyck is best known today for his portraits of the Genoese, Flemish and English aristocracy, he also enjoyed great contemporary success as a religious artist, painting major altarpieces for churches and chapels in Palermo, Genoa, Courtrai, Brussels and elsewhere. He had a deep personal faith and like so many Catholic painters of the time was profoundly influenced by the ideas of the Counter-Reformation.

Charity was painted by van Dyck soon after 1627 when he returned to his native Antwerp from a long stay in Italy. The subject had been treated by many Renaissance artists, among them Michelangelo and Raphael, but van Dyck's composition also reveals his study of the work of contemporary Italian painters, particularly Guido Reni. However, as is so often the case in van Dyck's work, his greatest debt, in palette and technique, is to Titian, the artist he admired above all others. *Charity* was a very successful composition: there are two versions by van Dyck himself and it was engraved by Cornelis van Caukercken shortly after van Dyck's death.

The National Gallery painting was purchased in Antwerp in 1763 by Captain Baillie from the Goubau family on behalf of Sir James Lowther. It remained in the collection of his descendants, the Earls of Lonsdale at Lowther Castle, until its purchase by the National Gallery under private treaty sale arrangements in 1984.

PLATE 36

Anthony van Dyck (1599–1641)

William Feilding, 1st Earl of Denbigh

Canvas, 247.5 × 148.5 cm.

Presented by Count Antoine Seilern, 1945

William Feilding (around 1582–1643) was a courtier of James I and then of his son, Charles I. His position at court depended on his being brother-in-law of James's favourite, George Villiers, who was created Duke of Buckingham in 1623. Feilding was appointed Master of the Great Wardrobe and created Earl of Denbigh in 1622. He travelled with Buckingham and the Prince of Wales to Madrid in 1623 during the unsuccessful negotiations for Charles's marriage to the Infanta, and subsequently held several naval commands. After Buckingham's assassination in 1628, Denbigh commanded the abortive expedition to relieve La Rochelle.

Between 1631 and 1633 Denbigh travelled to Persia and India. It was an unusual and adventurous undertaking and van Dyck's portrait was commissioned to commemorate the trip after his return. He is wearing a silk Indian jacket and pyjamas and carries a fowling-piece. He is out hunting and his Indian servant is showing him a parrot – a parrot in captivity would have been a familiar enough sight to Denbigh but not in the wild. He registers his surprise and delight by the gesture of his outstretched left hand.

Denbigh died in April 1643, fighting on the Royalist side in the Civil War. His paintings passed to the Duke of Hamilton who had married Denbigh's eldest daughter. This portrait was in the Hamilton sale of 1919. It was purchased in 1938 by the great collector and scholar of Flemish seventeenth-century painting, Count Antoine Seilern, and presented by him to the National Gallery in 1945.

PLATE 37

Anthony van Dyck (1599–1641)

The Abbé Scaglia adoring the Virgin and Child

Canvas, oval, approximately 106.7 × 120 cm.
Presented by Anthony de Rothschild in memory of Louisa, Lady de Rothschild, and Constance, Lady Battersea, 1937

Van Dyck returned from England for a stay in his native Flanders in 1634. He lived principally in Brussels and while there was commissioned by the Abbé Scaglia to paint three pictures: a full-length portrait of the Abbé (now in a private collection in England); a *Lamentation over the Dead Christ* (now in the Museum voor Schone Kunsten in Antwerp); and this *Virgin and Child* with the Abbé in adoration.

Cesare Alessandro Scaglia was a diplomat in the service of the House of Savoy. He was granted the sinecure position and the income of Abbot of Staffarda in Piedmont in about 1615. He was the Duke of Savoy's ambassador in Rome from 1614 to 1623 and in Paris from 1625 until 1627. His policy, which was anti-French, pro-British and pro-Spanish, was eventually made untenable by French military and diplomatic successes. He was ambassador in London briefly in 1631 but fell into dishonour with the duke. The following year he left London and went into retirement in Brussels.

In this painting the Virgin would seem to be a portrait of Christina of Savoy, the French duchess of Victor Amadeus I, and it may be that in having her shown in this way Scaglia was hoping to regain ducal favour. If so, he was unsuccessful as Scaglia was never again employed as a diplomat by the duke. He remained in Flanders, constantly intriguing, always on the fringes of diplomatic circles, and always in and out of painters' studios, until his death in 1641.

For the composition van Dyck turned to a page in the sketchbook he had kept during his years in Italy (the sketchbook is today in the British Museum). He had copied a now lost design by Titian of the Virgin and Child with a donor, and this he used as the basis of his painting.

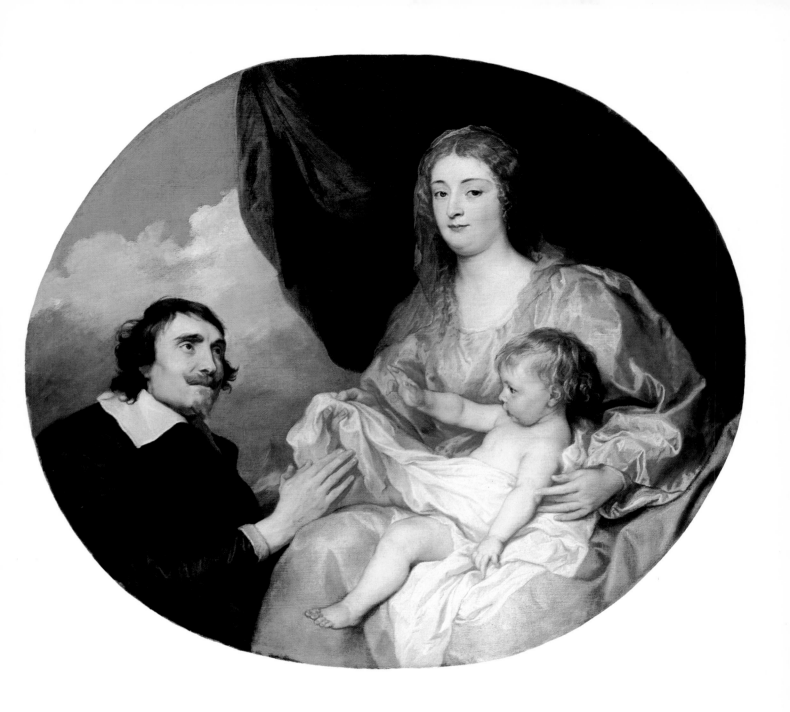

PLATE 38

Anthony van Dyck (1599–1641)

Carlo and Ubaldo see Rinaldo conquered by Love for Armida

Wood (oak), 57 × 41.5 cm.
Purchased with the Peel collection, 1871

The subject is from Torquato Tasso's long poem *Gerusalemme Liberata* (Jerusalem Liberated) which was first published in 1574. The crusaders Carlo and Ubaldo have been sent to find their companion Rinaldo and bring him back to their camp. Rinaldo has been bewitched by the sorceress Armida, who has taken him to the Fortunate Isles. In van Dyck's painting Carlo and Ubaldo in their Spanish-type helmets can be seen on the extreme left concealed behind foliage. Rinaldo lies in Armida's lap, entranced by her beauty. Around the couple are winged cupids assisting in and celebrating their love. Van Dyck follows Tasso's text – the story is told in stanzas 17 to 23 of canto 16 – only loosely, yet he is very close in spirit to the Italian poet in this representation of the scene, which is sensuous, romantic and full of touches of visual wit, such as the cupid trying on Armida's slipper in the bottom right-hand corner. Van Dyck, strikingly dissimilar in this respect from his mentor Rubens, had little feeling for the world of classical antiquity and it is unlikely that he read Latin and Greek authors with real pleasure and understanding. His modern Italian, however, was fluent and the Italian poets, Tasso, Ariosto and Guarini, had created ideal, heroic and romantic worlds with which van Dyck felt a profound sympathy. It was to these authors that he turned for inspiration rather than to Virgil or Tacitus.

Van Dyck painted a large-scale version of this composition for Frederick Henry, Stadholder of Holland. It is described in a 1632 inventory of the Stadholder's palaces as "Mars and Venus", an understandable confusion as van Dyck has introduced elements from the story of the god of war and the goddess of love into the painting. That painting is today in the Louvre. The National Gallery painting is an oil sketch, or *modello*, for the engraving which was made of the composition by Pieter de Jode the Younger. It was usual for small *modelli* to be painted in grisaille and to be squared up to assist the engraver. This *modello* was probably painted by van Dyck during his stay in Flanders in 1634–5. He may well have corrected the plate of de Jode's engraving when he again returned to Antwerp from England in 1640. The engraving was eventually published in 1644, three years after van Dyck's death.

PLATE 39

Anthony van Dyck (1599–1641)

Lady Elizabeth Thimbelby and Dorothy, Viscountess Andover

Canvas, 132.1 × 149 cm.

Purchased by private treaty from Earl Spencer, 1977

One of the greatest triumphs of van Dyck's years in England were his double portraits. He was able to balance, compositionally, colouristically and psychologically, a pair of sitters so as to give equal individuality and presence to each.

In this double, three-quarter-length group the sitters are the second and third daughters of Thomas, Viscount Savage. In April 1637 Dorothy married, against his father's wishes, Charles, Lord Andover, heir to the Earl of Berkshire. The younger sister, Elizabeth, here standing on the left, had married Sir John Thimbelby of Irnham, Lincolnshire, in 1634. The portrait was probably painted to mark Dorothy's wedding: the cupid presenting her with roses, the flowers of Venus, is an allusion to her marriage. The cupid rushes in from the left adding a sense of drama to the almost too well-balanced composition. It is the finest passage in the painting and precursor of the Cupid in the magnificent *Cupid and Psyche* in the Royal Collection, van Dyck's only mythological painting from his English period.

The painting was one of the many van Dycks owned by Sir Peter Lely, who modelled his style on that of van Dyck and succeeded him as court painter. It was purchased at the sale of Lely's collection in 1684 by the Earl of Sunderland. It hung for over two hundred years at Althorp, the seat of the Earls Spencer, until its sale to the National Gallery in 1977. It is still in the frame in which it was placed by the 1st Earl of Sunderland.

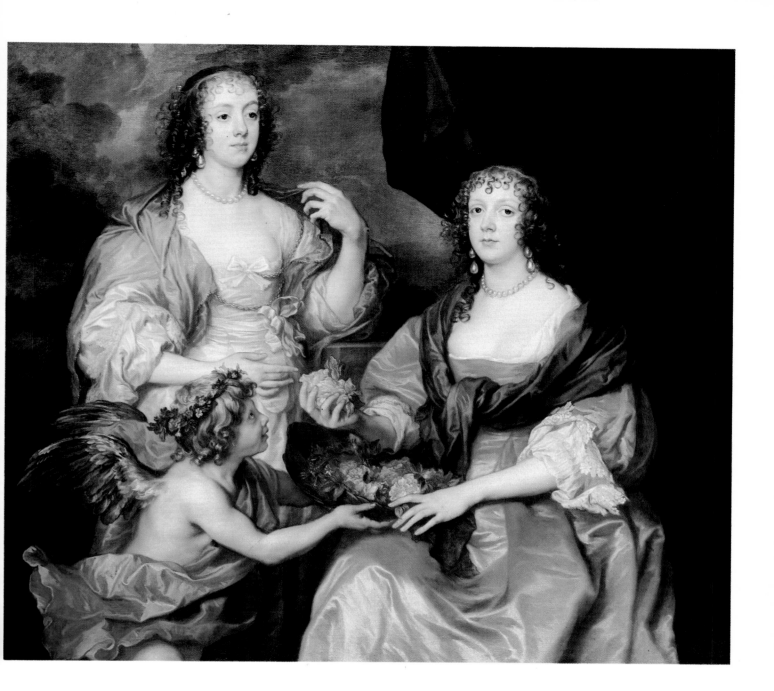

PLATE 40

Anthony van Dyck (1599–1641)

Equestrian Portrait of Charles I

Canvas, approximately 367 × 292.1 cm.
Purchased, 1885

Van Dyck painted two portraits of Charles I on horseback that are among the very greatest achievements of equestrian portraiture. The second one, which shows Charles riding through a triumphal arch accompanied on foot by his French riding-master, is in the Royal Collection. The depiction of a man on the back of a walking or rearing horse had taxed the ingenuity of the greatest Renaissance and Baroque artists. Van Dyck surmounted the technical problems with ease. Preparatory drawings show him examining unerringly the more difficult areas of the horse's anatomy – the head, the folds of flesh between the front legs, the joints of the legs – and these are rendered with no hint of awkwardness in the finished paintings.

The tablet which hangs in the branches of the tree is inscribed CAROLVS ./ REX MAGNAE BRITANIAE, a title which his father, James I, had been the first British sovereign to enjoy. The portrait is an exercise in royal propaganda and shows the king as Warrior Knight. Emphasising Charles's title as King of England, Scotland, Ireland and France, the pose deliberately echoes the famous antique statue of the Emperor Marcus Aurelius on horseback and Titian's great equestrian portrait of the Emperor Charles V in armour as the victor of the battle of Mühlberg. Charles wears on a gold chain around his neck a medallion which identifies

him as the Garter Sovereign riding, as it were, at the head of his chivalrous knights. The portrait, therefore, is also a visual statement of Charles's assertion of Divine Kingship.

If we compare Charles's head to that in other, earlier portraits by van Dyck, we can see that the painter has softened and ennobled his features. Even contemporaries remarked on the king's air of melancholy and later writers saw in this an aura of his impending martyrdom. Yet when this equestrian portrait was painted, in 1637 or 1638, Charles's troubles were still far away and the early years of his personal rule were a time of apparent political triumph. Melancholy cannot therefore have been intended to be the mood of the portrait, though van Dyck did mean to show the king in an attitude of contemplation, serious and abstracted, removed from mundane concerns. Dignity and nobility are the keynotes of the portrait.

In 1639 the painting was recorded as hanging in the Prince's Gallery at Hampton Court Palace. After the disposal of the Royal Collection under the Commonwealth the painting eventually passed into the collection of the Elector of Bavaria. Looted from Munich by the Emperor Joseph I, it was presented by him to John, Duke of Marlborough in 1706. It was sold to the National Gallery by the 8th Duke of Marlborough in 1885.

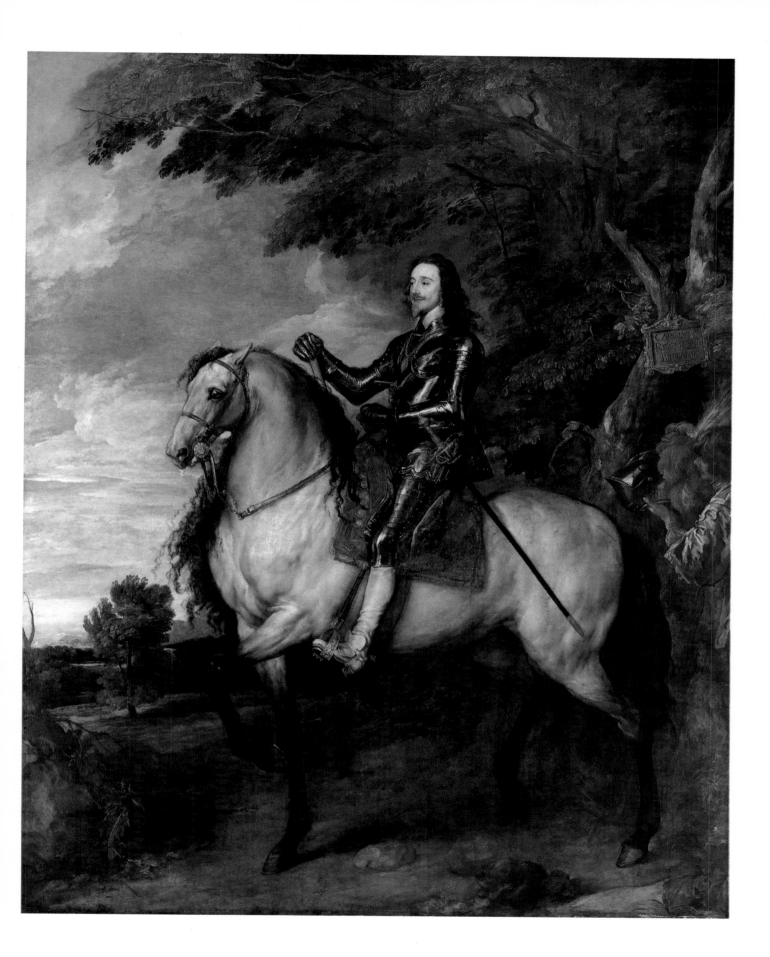

PLATE 41

Jacob van Oost the Elder (1601–1671)

Portrait of a Boy aged Eleven

Signed, inscribed and dated: AETAT (AE in monogram): SVAE (AE in monogram) ii
1650. IVO. (VO in monogram)
Canvas, 80.5 × 63 cm.
Purchased, 1883

The charm of this young boy, the muted colours of
the portrait and the artist's skill in the depiction of
the contrasting textures of fur, hair and skin have
combined to make this one of the best-loved
Flemish paintings in the National Gallery. Jacob
van Oost the Elder was principally a painter of
large-scale religious works, a number of which can
today be seen in the museum in his home-town of
Bruges. He is listed in the records of the guild of
Saint Luke in Bruges as a pupil of his elder brother,
Frans, in 1619 and two years later as a master.
Shortly after, as was normal among young Flemish
painters of the time, he set out on a visit to Italy. He
had returned to Bruges by 1628 and worked there,
achieving no more than local success, until his
death. Van Oost also painted portraits of the
merchant families of Bruges: they are competent
and unadventurous. His sitter in this portrait,
painted in 1650, is presumably the son of one of
these families. Here, however, particular circum-
stances – the boy's abstracted look, his fur muff and
hat, the background against which he is painted –
have caused van Oost to rise above his usual level of
provincial competence to create a haunting and
beautiful image.

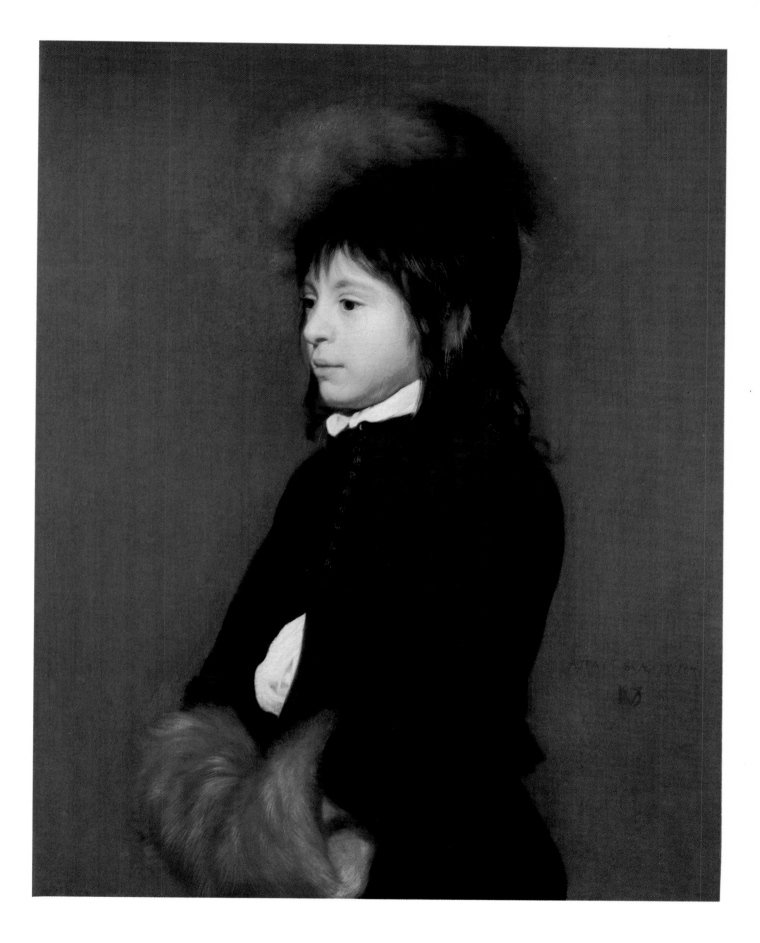

PLATE 42

David Teniers the Younger (1610–1690)

Two Men playing Cards in the Kitchen of an Inn

Signed: DAVID TENIERS F

Wood (oak), 55.5 × 76.5 cm.

Salting Bequest, 1910

David Teniers was an immensely successful artist. Born in Antwerp, he was the son of a painter, David Teniers the Elder, and trained in his father's studio. He was court painter to the Archduke Leopold Wilhelm, Governor of the Netherlands, and his successors, and also worked for the King of Spain and the Prince of Orange. He emulated Rubens in the purchase of a country estate and in the adoption of the *persona* of a country gentleman. Teniers was even awarded a patent of nobility in 1680.

Scenes of peasant life constitute by far the largest single type of subject matter painted by Teniers. There seems to have been a large and constant demand in the southern Netherlands (as there also was in the north) for paintings showing country people eating, drinking, fighting, playing cards and so on. It is not clear why these paintings were so popular, though in the first place their realism (to which the twentieth-century viewer is thoroughly attuned) must have seemed astonishing. We do not know whether a contrast was intended between such humble scenes and the grander houses in which they hung, or whether prosperous town-dwellers of peasant stock viewed such paintings nostalgically.

What is particularly striking in this outstanding example, which was probably painted in the late 1630s, is the opportunity the subject provided for the artist's skill: the still lifes in the foreground at the left and right are described with painstaking care. The composition, too, is carefully balanced, with the gamblers set off slightly to the left to counterpoint the background scene on the right. The modelling of the heads of the two old men playing cards, caught in a fall of light, are handled with remarkable assurance. The animated expressions of the onlookers, the glimpse into a light-filled room beyond the second room, the pewter pot and abandoned slippers – all combine to make this one of Teniers' finest treatments of a type of subject of which he is the greatest Flemish exponent.

David Teniers the Younger (1610–1690)

Spring ; Summer ; Autumn ; Winter

The first three signed: DT·F (DT in monogram); the fourth signed: DT (in monogram)

Copper, approximately 22 × 16 cm.

Purchased with the Peel collection, 1871

It was traditional in sixteenth-century Flemish art to represent the four seasons by female personifications holding symbolic objects. In the seventeenth century, however, the same subjects were represented in a naturalistic manner as here by Teniers. So Spring, rather than being shown as a half-naked woman holding flowers, is represented by a gardener about to plant a tree. Spring is a particularly interesting scene in this series as the background provides a rare glimpse of a formal garden being laid out. Teniers intends a deliberate contrast between nature tamed by the hand of man on one side of the fence and wild beyond. Formal gardens, as created by André Le Nôtre at Versailles, had become popular in the Netherlands: one of the finest examples, recently restored to its original

splendour, is at the palace of Het Loo near Apeldoorn in Holland.

Summer is represented by a farm labourer binding up the ripe corn; Autumn by a tavern landlord raising a glass of the new vintage, with, on the right, a scene of grapes being trodden and barrels of wine being sealed; and Winter by an old man dressed in furs warming himself over a brazier, with skaters in the background.

Some of Teniers' larger pictures seem somewhat empty in composition and lacklustre in the application of paint. The small scale of these four copper panels, however, marks his painting style to perfection: the handling is marvellously animated and sketchy, yet full of telling detail. They were probably painted in about 1644.

PLATE 44

David Teniers the Younger (1610–1690)

A View of Het Sterckshof near Antwerp

Signed: D·TENIERS·F
Canvas, 82 × 118 cm.
Purchased, 1871

Traditionally this painting was thought to show De Drij Toren (The Three Towers), the house at Perck that Teniers himself bought in 1662. Recently, however, it has been shown that the house is Het Sterckshof at Deurne near Antwerp. The towers and stepped gables of the house provide a backdrop to the foreground figures. On the left is a group of three well-dressed individuals, among whom perhaps is the owner of the house, receiving a fish from an elderly peasant. It has just been caught by the fishermen who are at work with their nets on the right. Stylistically the painting can be dated to about 1646 and at this time the owner of Het Sterckshof was Jacob Edelheer, who in 1644 had married its heiress, Isabella van Lemens. It is possible therefore that the figures are meant as portraits of Edelheer, his wife and a female relative. On the other hand, the painting could be simply a leisurely scene from rural life with Het Sterckshof providing an appropriate and picturesque setting.

PLATE 45

David Teniers the Younger (1610–1690)

The Covetous Man

Signed: DAVID·TENIERS
Canvas, 62.5 × 85 cm.
Bequeathed by Lord Farnborough, 1838

Teniers is best known for his scenes of peasant life, but he also painted and etched religious subjects and landscapes as well as designing tapestries. This painting, which probably dates from about 1648, is a condemnation of miserliness and undue attention to temporal rather than spiritual values. It illustrates the text of Luke, chapter 12, verses 20–21: "But God said unto him, Thou fool, this night thy soul shall be required of thee: then whose shall those things be, which thou hast provided? So is he that layeth up treasure for himself, and is not rich toward God".

The illustration of such sentiments was traditional in Antwerp painting. Quentin Massys, for example, had painted a *Money Changers* scene with a similar moral intention. Indeed, so conventional were such representations that we might wonder about their effectiveness. Certainly Teniers himself, with his lavish way of life and his passionate desire to become a noble, does not seem to have taken to heart the message of his own painting.

PLATE 46

Gonzales Coques (1614 or 1618–1684)

A Family Group out of doors

Canvas, approximately 64.2 × 85.5 cm.
Purchased with the Peel collection, 1871

Gonzales Coques lived and worked in Antwerp. He enjoyed a successful career as a portrait and figure painter although he never achieved the immense international acclaim of Rubens, van Dyck and Jordaens. Among his patrons were, however, the Prince of Orange and his work was admired by the Archduke Leopold-Wilhelm and Don Juan of Austria, successive Spanish governors of the southern Netherlands. Such admiration can easily be understood when we look at this charming and delicately painted family group, which was probably executed around 1664. It is composed in a conventional manner, with the smallest children at the edge of the group so their heads form diagonals leading the spectator's eye to those of their parents. Within this formula, however, Coques manages to give an air of relaxed informality to the figures. One child plays with a captive bird on a T-shaped perch, another plays a cittern, while a third pushes along the baby of the family in a walking-aid known as a *loopstoel*. The eldest daughter gathers roses in a basket: roses were known as the flowers of Venus and this may well be an allusion to her forthcoming marriage. The pose of the father is dignified and yet, pointing with pride to the baby (who may be the only boy), it is also intensely human and affectionate.

The family's identity has unfortunately been lost, though they were clearly very prosperous as can be judged not only by their clothes but also by the imposing portico of their house and the ornamental fountain in front of it. Coques painted portraits of the richer citizens of his native Antwerp and this family were presumably among them. The whole group is painted with a lightness of touch – the faces animated, the dresses shimmering – and a richness of contrasted colour that place it among Coques' most outstanding works.

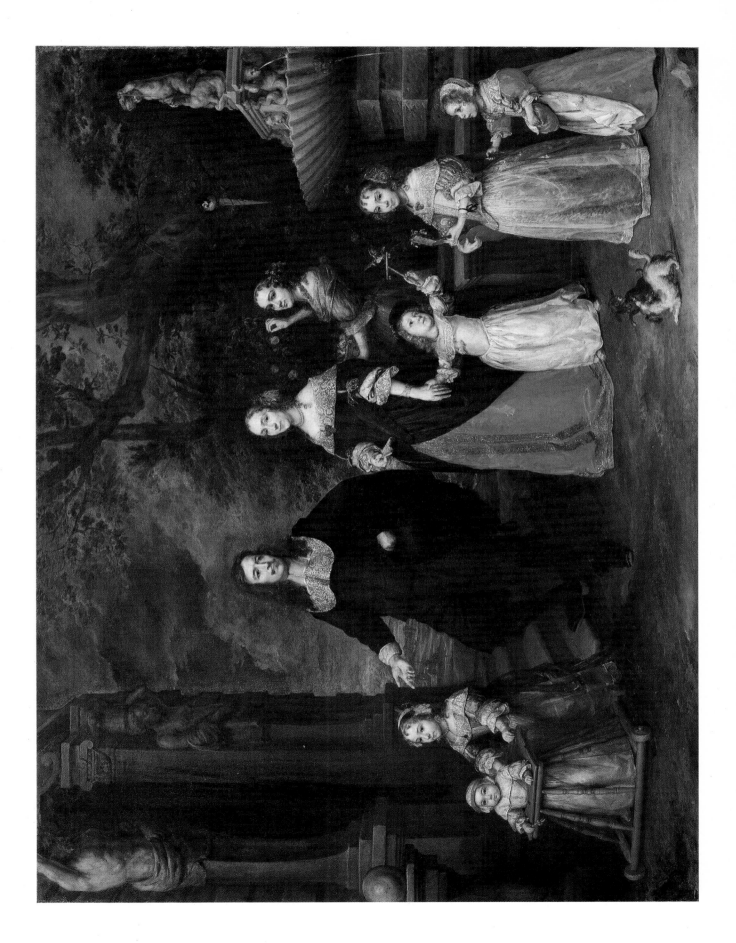

PLATE 47

Gonzales Coques (1614 or 1618–1684)

Portrait of a Woman as Saint Agnes

Silver, 18.3 × 14.4 cm.
Wynn Ellis Bequest, 1876

This small, delicate portrait painted on silver – an unusual and precious support – shows its subject in the guise of Saint Agnes. She is identified by her attributes of a sword, the instrument of her martyrdom, and a lamb. Her identification as Saint Agnes could either refer to her marriage, as Agnes was the patroness of the betrothed, or to her Christian name. It was not uncommon in the seventeenth century for sitters to be portrayed in the guise of their name saint, but although it is possible that this lively, almost pert, young woman was called Agnes, her precise identity is unknown.

A clue to her family name might be provided by the distinctive portico behind her. It appears to be the one designed by Rubens to join the two wings of his house in Antwerp, where it can still be seen today. There are a few differences in detail but essentially it is the same black and white structure with rusticated columns, antique busts in the niches and figures of satyrs in the spandrels. Rubens' house had been bought in 1660 by Jacob van Eycke, who died ten years later. His widow, Cornelia Hillewerve, sold it in 1680 to her brother, Canon Hendrick Hillewerve. The portrait probably dates from about 1680, so it may be that this young woman is a member of the Hillewerve family.

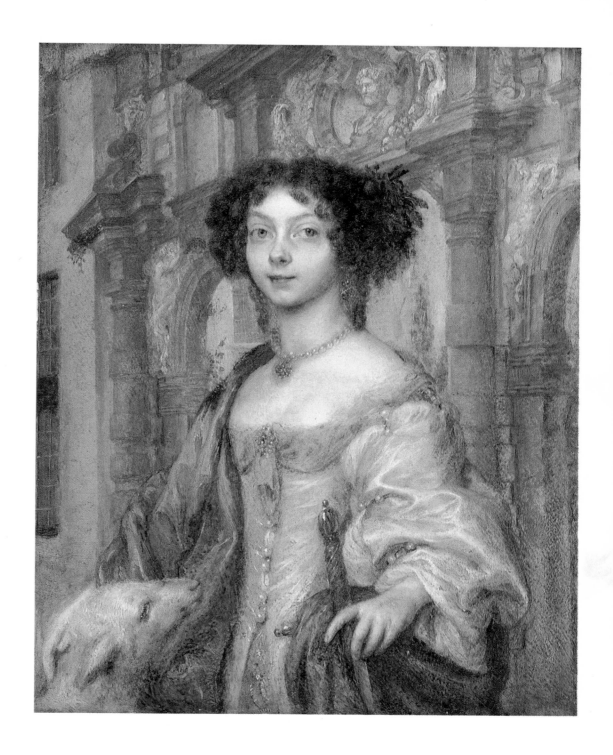

PLATE 48

Willem van Herp the Elder (1614[?]–1677)

Saint Anthony of Padua distributing Bread

Signed: C·V·HERP
Copper, 80 × 114.3 cm.
Bequeathed by Richard Simmons, 1846

Van Herp is a little-known Antwerp artist whose works are rare, but it is evident from this large, attractive and well-preserved picture on copper that he was a skilful painter of narrative religious subjects. He was probably born in Antwerp, although no baptismal record has been traced, and he became a master of the guild in the year 1637/8. He married the daughter of another Antwerp painter, Artus Wolffort, and his two sons became painters. There were many such artistic "dynasties" in seventeenth-century Antwerp.

The brown-robed friars distributing bread are Franciscans. The one in the centre has a glory and is probably Saint Anthony of Padua (1195–1231), who was famed for his charitable works. Among the figures on the right are two pilgrims: the man is identified by the gourd attached to his staff and the pilgrim's scallop shells in his hat. A document records that van Herp was paid for a painting of this subject on copper by an Antwerp art dealer in 1662 and this may well be the same picture.

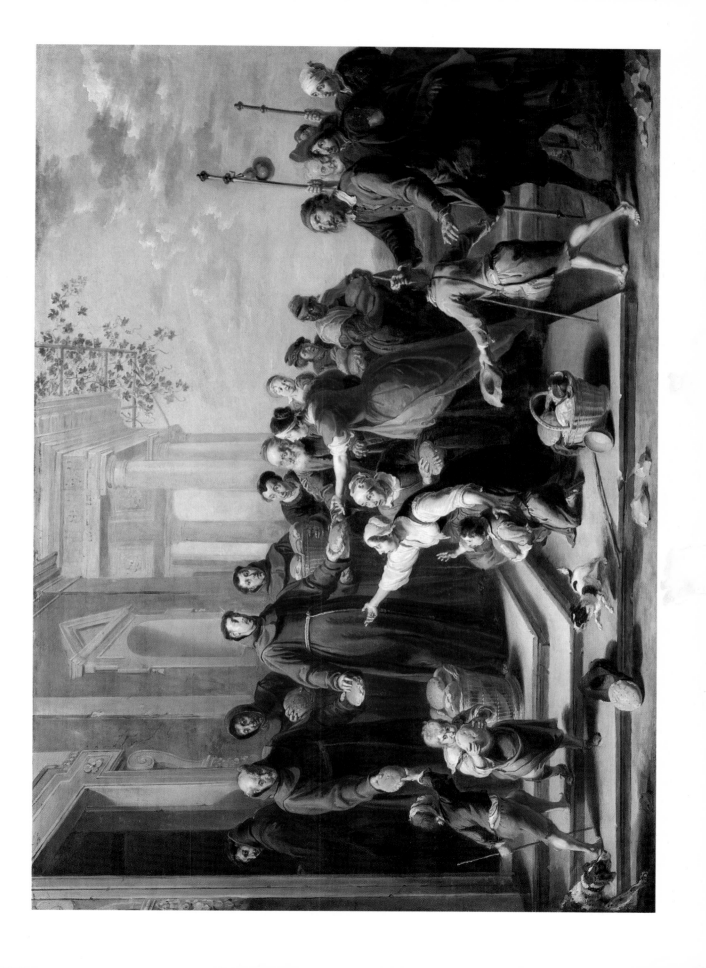

PLATE 49

Jan Siberechts (1627–1700 or around 1703)

A Cowherd passing a Horse and Cart in a Stream

Signed and dated: J. Siberechts. A·aneurs·165(?) 8(?)
Canvas, approximately 63.8 × 54.3 cm.
Presented by John P. Heseltine, 1907

Jan Siberechts was one of a number of Netherlandish artists who came to work in England during the seventeenth century. He had been born and trained in Antwerp and did not move to London until 1672, a year of economic distress in the Netherlands. While in England he specialised in the topographical paintings of country houses that were so much in demand. Siberechts died in London, although the exact date is not known.

Before leaving Antwerp, Siberechts painted figures in landscapes, usually country people going to or returning from market. This is an excellent example of his Antwerp style, the cart stacked high with market produce. Siberechts' figure painting is rather primitive – in this scene the sizes of individual figures seem unrelated to one another – but he is a skilful painter of landscape, particularly of willows along the edges of streams, and his evocation of country life possesses a distinct, though naïve, charm.

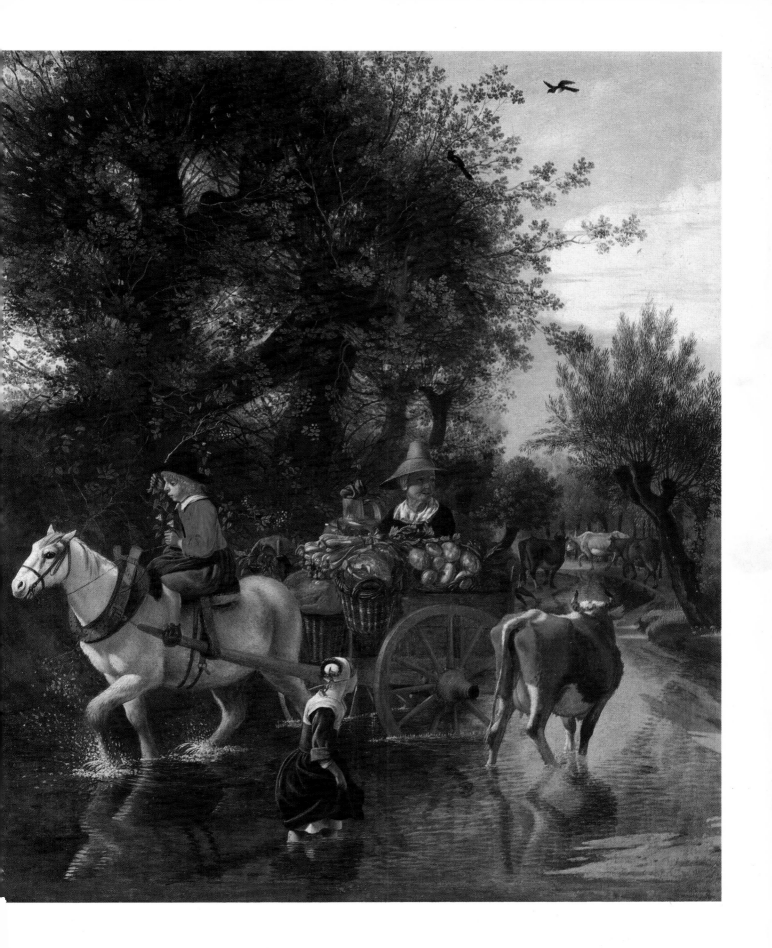

PLATE 50

Adam-François van der Meulen (1632–1690)

Philippe-François d'Arenberg saluted by the Leader of a Troop of Horsemen

Signed and dated: A.F.V. MEVLEN.FEC: 1662.BRVXEL.
Canvas, 58.5 × 81 cm.
Purchased, 1895

Van der Meulen, who was born in Brussels and entered the painters' guild there in 1651, specialised in topographical views, naval scenes and battles. In 1664, shortly after painting this picture, he entered the service of Louis XIV for whom he depicted many of the battles fought by the French in the Netherlands. He also designed tapestries for the Gobelins factory. He died in France, at the Hôtel des Gobelins.

Before moving to France, van der Meulen was in demand at the court in Brussels. Philippe-François, 1st Duke of Arenberg and Duke of Arschot and Croy (1625–1674), was an important figure there. He had served in the army of the southern Netherlands and had distinguished himself at the siege of Arras in 1654. He had been appointed Captain-General of the Flemish fleet and in 1663, the year after this picture was painted, was made *grand bailli*, Governor and Captain-General of Hainault. He is the man seated prominently within the coach: the outrider to the right wears his colours of yellow and red.

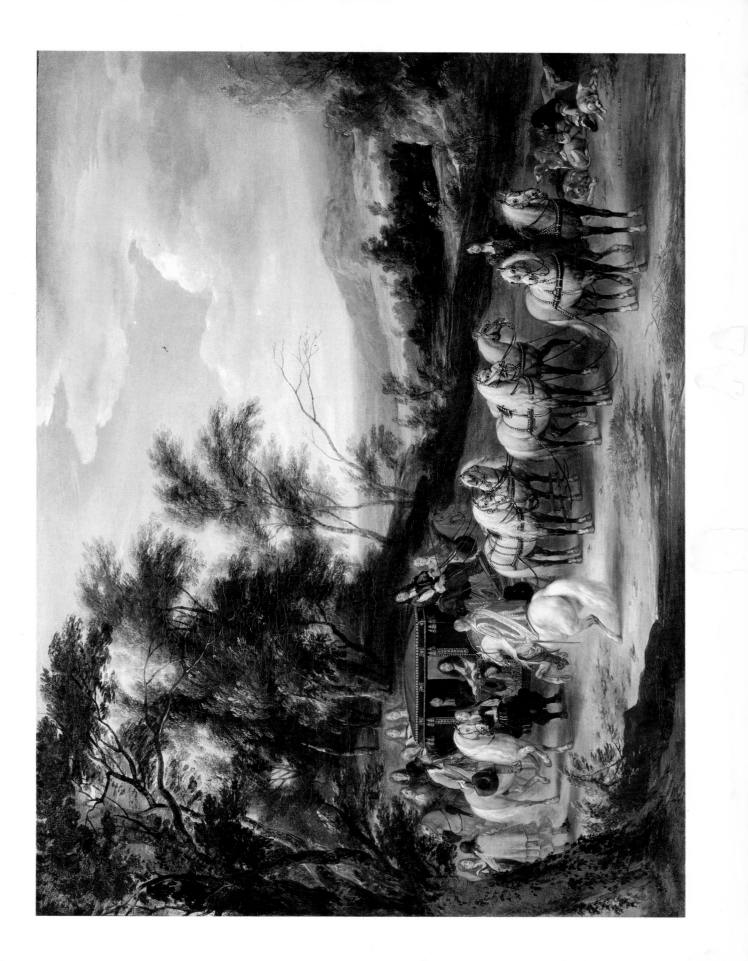

Index to Plates

Note : the plates are listed alphabetically by the name of the artist